Big School of Drawing
Manga, Comics
& Fantasy
Workbook

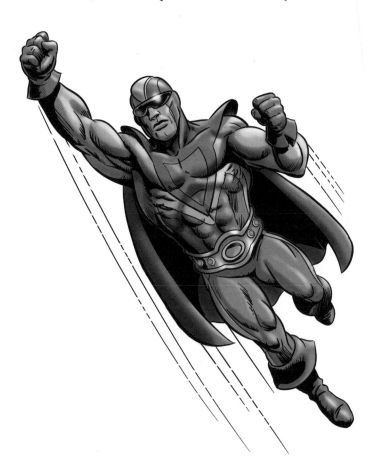

Exercises and step-by-step drawing
lessons for the beginning artist

Contents

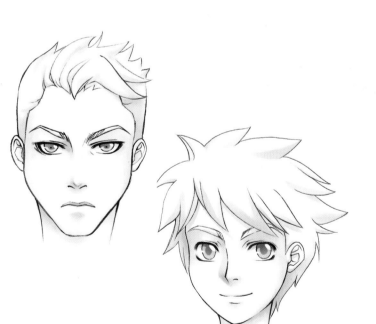
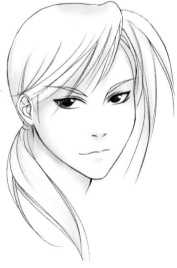
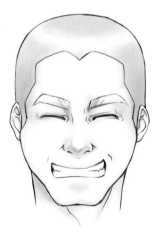

Introduction

Welcome to Big School of Drawing Manga, Comics & Fantasy Workbook!

This exercise book guides you step by step through a range of drawing techniques and projects. Starting with basic drawing techniques, such as creating textures, adding color, and drawing heads, hair, and facial expressions, you can then try out your newfound skills directly inside the book with approachable step-by-step projects, including manga heroines and heroes, superheroes and villains, mythical creatures, and more.

Surely you've heard the phrase "practice makes perfect." This statement rings true for drawing as much as any other skill. If you follow the exercises and projects in this book, you'll soon see great improvement in your pencil techniques and character development. Whether you are following along step by step or using the techniques to create your own unique characters, let inspiration guide you as you add personality and detail to your drawings. When drawing manga, comics, and fantasy characters, there are no limits to your imagination.

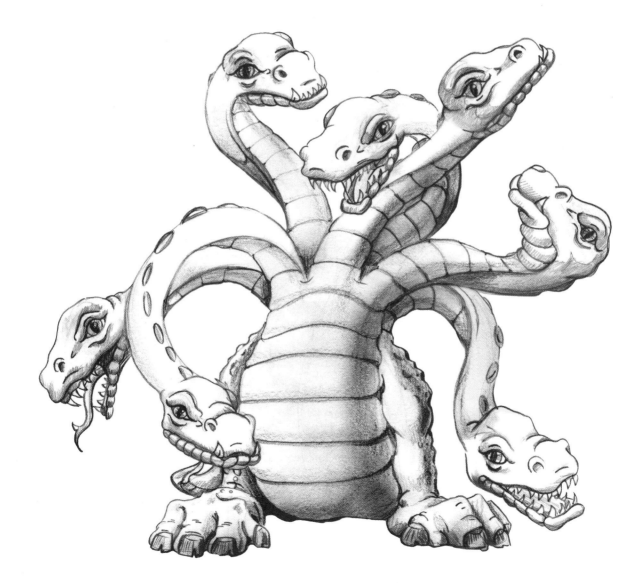

Basics
Linework & Shading

PRACTICING LINES

When drawing lines, it is not necessary to always use a sharp point. In fact, sometimes a blunt point may create a more desirable effect. When using larger lead diameters, the effect of a blunt point is even more evident. Play around with your pencils to familiarize yourself with the different types of lines they can create. Make every kind of stroke you can think of, using both a sharp point and a blunt point. Practice the strokes below to help you loosen up. As you experiment, you will find that some of your doodles will bring to mind certain imagery or textures. For example, little Vs can be reminiscent of birds flying, whereas wavy lines can indicate water.

DRAWING WITH A SHARP POINT

First draw a series of parallel lines. Try them vertically, and then angle them. Make some of them curved, trying both short and long strokes. Then try some wavy lines at an angle and some with short, vertical strokes. Try making a spiral and then grouping short, curved lines together. Then practice varying the weight of the line as you draw.

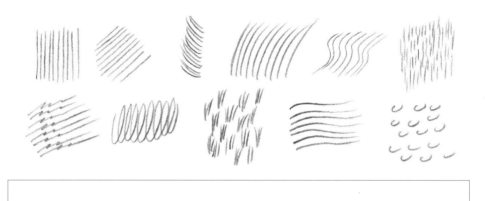

DRAWING WITH A BLUNT POINT

Even if you use the same hand positions and strokes, the results will be different when you switch pencils. Take a look at these examples. The same shapes were drawn with both pencils, but the blunt pencil produced different images. You can create a blunt point by rubbing the tip of the pencil on a sandpaper block or on a rough piece of paper.

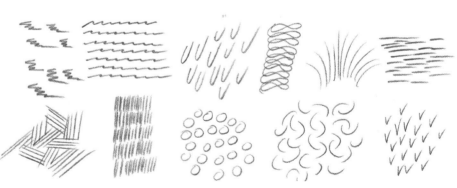

"PAINTING" WITH PENCIL

When you use painterly strokes, your drawing will take on a new dimension. Think of your pencil as a brush, and allow yourself to put more of your arm into the stroke. To create this effect, try using the underhand position, holding your pencil between your thumb and forefinger and using the side of the pencil. If you rotate the pencil in your hand every few strokes, you will not have to sharpen it as frequently. The larger the lead, the wider the stroke will be. The softer the lead, the more painterly an effect you will have. These examples were all made on smooth paper with a 6B pencil, but you can experiment with rough papers for more broken effects.

Starting Simply First experiment with vertical, horizontal, and curved strokes. Keep the strokes close together, and begin with heavy pressure. Then lighten the pressure with each stroke.

Varying the Pressure Randomly cover the area with tone, varying the pressure at different points. Continue to keep your strokes loose.

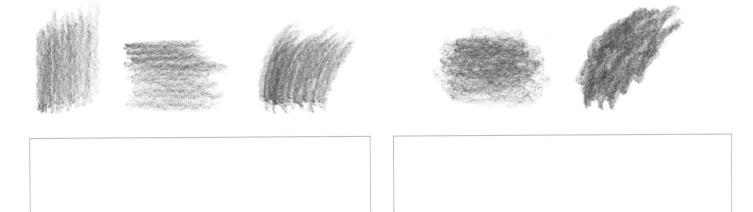

Using Smaller Strokes Make small circles for the first example. This is reminiscent of leathery animal skin. For the second example (at right), use short, alternating strokes of heavy and light pressure to create a pattern that is similar to stone or brick.

Loosening Up Use long vertical strokes, varying the pressure for each stroke until you start to see long grass (left). Then use somewhat looser movements that could be used for water (middle), or create short spiral movements with your arm, and then use a wavy movement, varying the pressure (right).

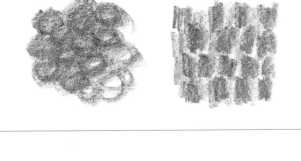

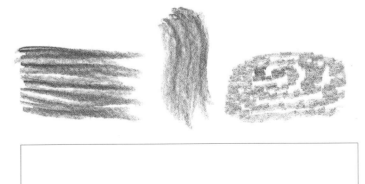

Creating Textures

Textures are not entities that exist on their own; they are attached to a form and are subject to the same basic rules as all other forms. A texture should be rendered by the way it is affected by the light source and should be used to build the form on which it lies. Texture shouldn't be confused with pattern, which is the tone or coloration of the material. Haphazardly filling an area with texture will not improve a drawing, but using the texture to build a shadow area will give the larger shape its proper weight and form in space. You should think of texture as a series of forms (or lack thereof) on a surface. Here are some examples to help you.

Cloth The texture of cloth will depend on the thickness and stiffness of the material. Thinner materials will have more wrinkles that bunch and conform to shapes more perfectly.

Long Hair Long hair, like cloth, has a direction and a flow to its texture. Its patterns depend on the weight of the strands and stress points. Long hair gathers into smaller forms—simply treat each form as its own sub-form that is part of the larger form.

Scales Drawn as a series of interlocking stacked plates, scales will become more compressed as they follow forms that recede from the picture plane. Use a similar technique to create armor and chainmail.

Wood If left rough and not sanded down, wood is made up of swirling lines. There is a rhythm and direction to the pattern that you need to observe and then feel out in your drawings.

Short, Fine Hair Starting at the point closest to the viewer, the hairs point toward the picture plane and can be indicated as dots. Moving out and into shadowed areas, the marks become longer and more dense.

Metal Polished metal is a mirrored surface and reflects a distorted image of whatever is around it. Metal can range from slightly dull as shown here to incredibly sharp and mirror-like. The shapes reflected will be abstract with hard edges, and the reflected light will be very bright.

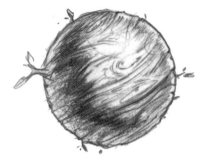

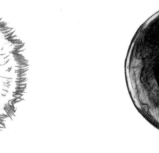

Feathers and Leaves As with short hair, stiff feathers or leaves are long and a bit thick. The forms closest to the viewer are compressed, and those farther away from the viewer are longer.

Curly Hair With curly hair, it's important to follow the pattern of highlights, core shadow, and reflected light. Unruly patterns will increase the impression of tangled hair or dreadlocks.

Rope The series of braided cords that make up rope create a pattern that compresses as it wraps around a surface and moves away from the picture plane.

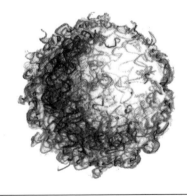

Inking Techniques

Inking is as important an element in creating great comics and manga art as character design, penciling, or storytelling. Great inking can add style and visual dynamics, even to less-than-perfect pencils. In the early days, inking was a necessity. Inking allowed images to be reproduced inexpensively using a very simple black-and-white photographic process. Early artists used rendering techniques borrowed from engraving to simulate tonality. Most inking was done with India ink, preferred for its extremely dense black. To create subtle tonal changes from solid black shadows to lighter areas, artists used hatching, crosshatching, or "feathered" brushstrokes or pen strokes. As the industry grew, artists started using other mediums, such as markers and even soft pencils. Still, the iconic look of manga- and comics-style art owes much to those early inking techniques.

TRADITIONAL TECHNIQUES

Master these basic inking techniques, and you'll be off to a great start in the fine art of inking! Once you have these traditional techniques down, try experimenting with different media and line-making. You can achieve a variety of looks with just a few tools and techniques.

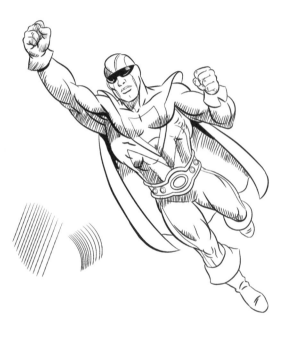

Hatching This simple inking technique uses fine or thick lines to describe the form of objects in a drawing. You can suggest shadows with hatch marks, and the lines can vary in thickness to indicate intensity of shadows or changes in the form of objects. The best tools for hatching are pens, although some inkers are very skilled at hatching with a brush.

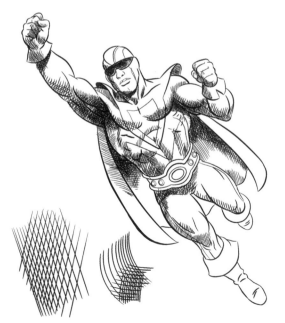

Crosshatching Introduce hatch lines at different angles to build up shadowing or show changes in surfaces. Try to avoid crosshatching at right angles, which can create a dull grid work that may detract from your drawing. As you can see in this example, crosshatching can follow contours to further suggest form, and multiple layers of crosshatching drawn at varying angles can create very subtle transitions in tonality.

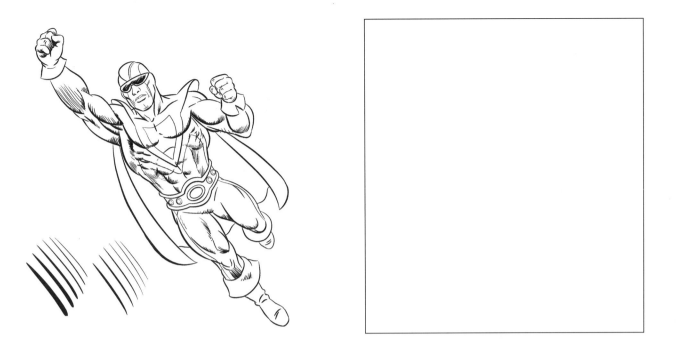

Feathering Generally done with a brush or quill pen, this technique uses varying pressure to create "thick-to-thin" strokes. Feathering can also be an effective way to render the outlines of figures. The thin-thick-thin line can suggest changes in contour or roundness and can even be used as a simple way to suggest shadow. The thin-thick-thin stroke requires controlling the pressure you apply when drawing the line. Whether you use a pen or a brush, the greater the pressure you apply as you draw, the thicker the line.

CONTEMPORARY TECHNIQUES

Many contemporary inkers and artists choose less-traditional inking methods. Because they require less skill and drying time, many artists prefer various fine and medium marker pens. Some marker pens can respond to changes in pressure and present like feathering.

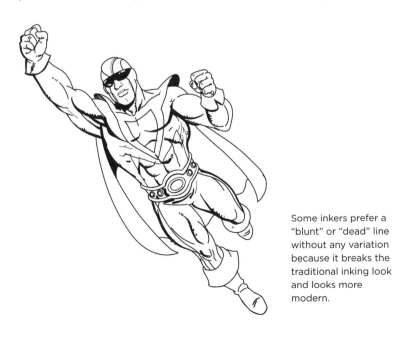

Some inkers prefer a "blunt" or "dead" line without any variation because it breaks the traditional inking look and looks more modern.

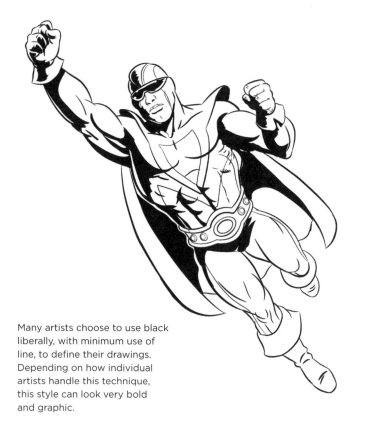

Many artists choose to use black liberally, with minimum use of line, to define their drawings. Depending on how individual artists handle this technique, this style can look very bold and graphic.

There are also rendering techniques such as stippling—fine dots used to shade a drawing—which may be used as a "special effect" or to indicate a certain kind of texture. This technique can look great, but it would be tedious to maintain over an entire drawing or comic.

Some artists choose to use little or no rendering in their work and rely only on the outlines to define their drawings. This can also be a very effective method, especially when color is used to further define the forms. This method is usually used for lighter subjects, such as cartoon-type characters.

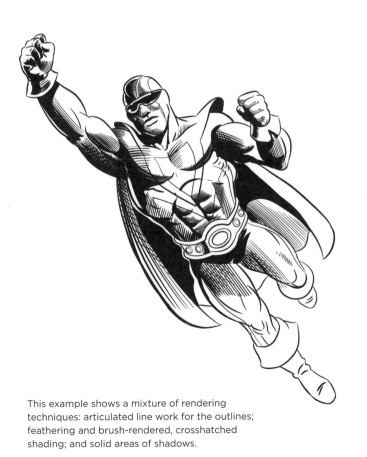

This example shows a mixture of rendering techniques: articulated line work for the outlines; feathering and brush-rendered, crosshatched shading; and solid areas of shadows.

Coloring

When coloring, work in layers—from the lightest colors to the darkest shadows. Be sure to make all your strokes in the same direction, and leave the brightest highlights white. Use markers to achieve a blocky coloring style common in *anime* (Japanese animation.) You may also try colored pencils, which work similarly to regular pencils, or digital coloring techniques for blending and various lighting effects.

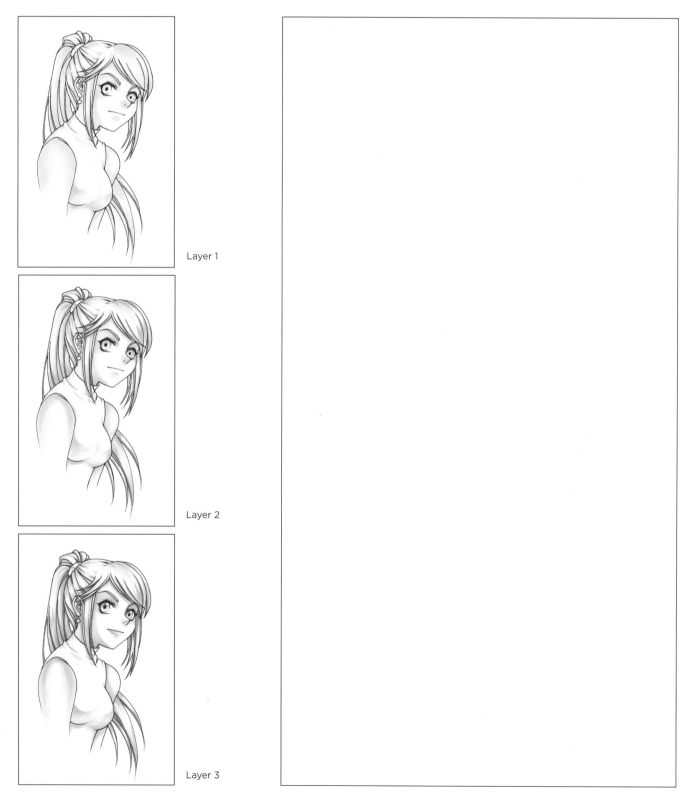

Layer 1

Layer 2

Layer 3

Digital Illustration

Digital illustration can result in highly detailed, dynamic artwork. Unlike drawing or painting, digital illustration allows you to make dramatic enhancements with just a few clicks of a mouse. It helps to have an understanding of the basic tools and functions of image editing software, such as Adobe Photoshop® (used in this book). Here are some basic functions you'll find helpful.

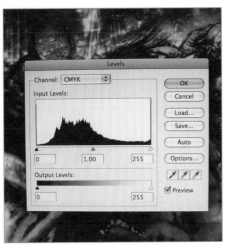

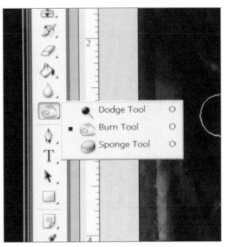

Image Resolution When scanning your drawing or painting into Photoshop, it's important to scan it at 300 dpi (dots per inch) and 100% the size of the original. A higher dpi carries more pixel information and determines the quality at which your image will print. However, if you intend for the image to be a piece of digital art only, you can set the dpi as low as 72. View the dpi and size under the menu Image > Image Size.

Levels With this tool (under Image > Adjustments), you can change the brightness, contrast, and range of values within an image. The black, midtone, and white of the image are represented by the three markers along the bottom of the graph. Slide these markers horizontally. Moving the black marker right will darken the overall image, moving the white marker left will lighten the overall image, and sliding the midtone marker left or right will make the midtones darker or lighter respectively.

Dodge and Burn Tools The dodge and burn tools—photography terms borrowed from the old darkroom—are also found on the basic tool bar. Dodge is synonymous with lighten; burn is synonymous with darken. On the settings bar under "Range" you can select highlights, midtones, or shadows. Select which of the three you'd like to dodge or burn, and the tool will only affect these tones. Adjust the width and exposure (or strength) as desired.

Eraser Tool The eraser tool is found in the basic tool bar. When working on a background layer, the tool removes pixels to reveal a white background. You can adjust the diameter and opacity of the brush to control the width and strength of the eraser.

Paintbrush Tool The paintbrush tool allows you to apply layers of color to your canvas. Like the eraser, dodge, and burn tools, you can adjust the diameter and opacity of the brush to control the width and strength of your strokes.

Color Picker Choose the color of your "paint" in the Color Picker window. Select your hue by clicking within the vertical color bar; then move the circular cursor around the box to change the color's tone.

Photoshop Tutorial

Here we'll go over how to digitally color in Adobe Photoshop®. Every artist works differently; if you have a different way of completing the steps illustrated in this project, that's great! This method is just one of many ways of creating awesome art in Photoshop.

Canvas
The canvas is your working area in Photoshop. Think of it as the digital paper on which you will create your masterpiece.

Dimensions
The dimensions of a document are the height and width of your canvas, or working area. This is also called "Document Size" in Photoshop.

Pixels
A pixel is basically one point in an image. Digital images are comprised of many pixels sitting next to each other, forming a "grid." If an image is 5000 pixels high and 2000 pixels wide, the total number of pixels is 10,000,000. Zoom in very close to any graphic in Photoshop, and you can see that the image is comprised of tiny colored squares. Each square is a pixel—the smallest possible unit of measurement in a digital image.

Resolution
Resolution is the number of pixels in each dimension that can be displayed. The resolution of an image is labeled with "height" and "width." The resolution of a 5000 x 2000 pixel image is "5000 x 2000."

DPI
DPI (dots-per-inch) is a measure of resolution in an image specifically for printing purposes. It is the number of pixels that can be put in a 1-inch (2.5 cm) space. The higher the dpi of an image, the more pixels per 1-inch (2.5 cm) line, which means there is more detail. Most online web images are 72 dpi. Photos or images printed in magazines are usually a minimum of 300 dpi and can be as large as 1200 dpi. If you plan to print your artwork, you should work on a canvas that is at least 300 dpi.

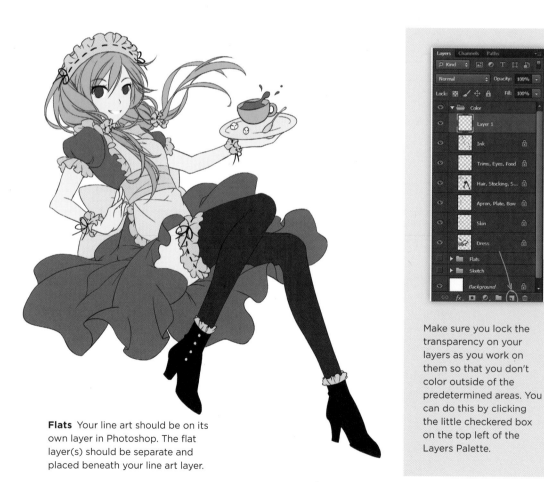

Flats Your line art should be on its own layer in Photoshop. The flat layer(s) should be separate and placed beneath your line art layer.

To make a new layer, click the paper-like icon on the bottom right of the Layers Palette.

Make sure you lock the transparency on your layers as you work on them so that you don't color outside of the predetermined areas. You can do this by clicking the little checkered box on the top left of the Layers Palette.

Painting Phase 1 Start your first layer of shading, using the "Soft Round," "Hard Round Pressure Size," and "Hard Round Pressure Opacity" (which are generally the default brushes in Photoshop). If you're using a pen tablet, the opacity will change with how hard you press on the tablet—you can achieve different opacities with this feature alone.

Painting Phase 2 Once you have your first layer of rendering complete, add more depth by introducing the next layer, as well as some new colors. To achieve depth, select darker colors for the shadowed areas and lighter colors for those hit with more light. Play around and experiment with other brushes. You can even make your own once you become familiar with Photoshop!

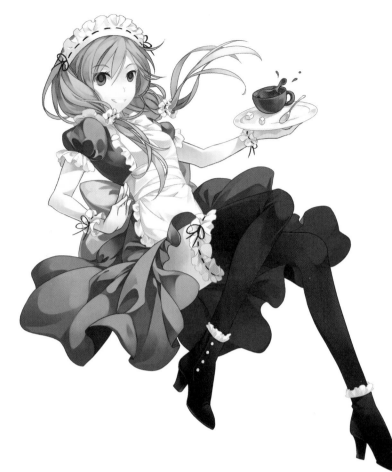

Coloring Line Art To lighten the overall weight of the black line art, try coloring it. This softens the image and makes it look less graphic and flat. Use colors similar to the area it surrounds. For example, use a light brownish color for the hair line art and a dark purple color for the dress line art.

Highlights & Final Details Add some highlights to your illustration to really make it pop! You can do this with one or several layers to build up the effect. Make a new layer and set it to "Overlay." Use soft brushes for smoother and softer highlights, such as the dress fabric, on one layer. Create sharper highlights, like the shiny gleams on the teacup, on another layer. Note that her hair has both a soft sheen and sharp highlights where the light hits. You can also draw some extra strands of hair for a more natural look. Color her pupils with dark blue on a layer set to "Normal."

DETAIL

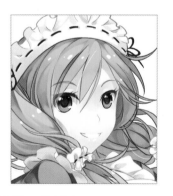

Add Eye Highlights
Add some shine to the eyes! You can use your other overlay layers or make a new one in the Layers Palette. Select a bright cyan color and brighten the bottom of the irises, as well as the corners and edge. Create a new layer set to "Normal" and add white highlights on all the eye layers, including line art. Don't completely cover the cyan highlights.

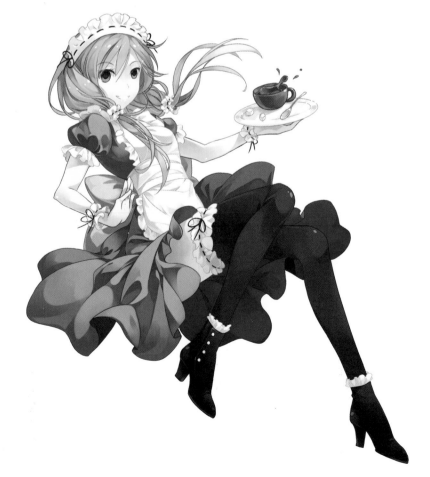

CREATE A CLIPPING MASK

A clipping mask is a setting that allows you to easily "hide" anything visible outside of the layer to which it is connected. For example, anything drawn on the "Light Blue" layer while it is clipped to the "Dress" layer will only be visible within the boundaries of the "Dress" layer. Anything drawn outside of that will be invisible.

Use the "Gradient" tool (or the "Soft Brush") to add a blue tint to the back of the dress. Make sure the "Gradient" tool is set to the fill type Foreground (color) to Transparent. Set your gradient layer to "Multiply" so the skirt has a blue tint but doesn't cover the rendering.

Add Gradient Colors to Skirt

Now it's time to play with some fun effects by adding a gradient to the bottom portion of the skirt. First make a new layer, and set it above the dress layer. Right-click on this layer, and select "Create Clipping Mask." (See right.)

Lighten Image with Levels

As a final touch, lighten the entire image so it has a softer, lighter feel. Rather than going back and manually editing each separate section, you can use an "Adjustments" layer to do it all at once. Click on the icon that looks like a circle divided in half on the bottom of the Layers Palette. A new layer should pop up on your Layers Palette, along with the "Levels" palette. To make your entire image lighter, click on the gray arrow on the Levels Palette and slide it to the left.

Comics
Bionic Hero

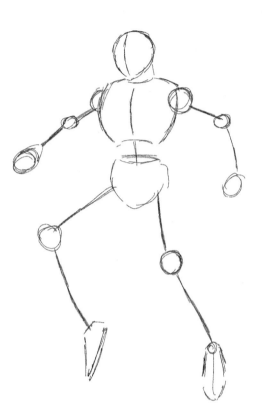

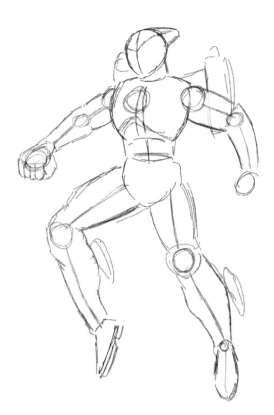

Step 1 Briskly sketch this pose. Then draw in the head, main body masses, and arms and legs, focusing on proportion and balance.

Step 2 Once you're happy with this character's position, start adding details to the supersuit. Then begin to fill out the body. Your bionic hero should have armor that is over-designed to withstand anything, so draw bulky shoulder joints and heavy gauntlets and leg armor. Give him an aerodynamic helmet and twin mini-jet turbines built right onto his back.

Step 3 Add more and more detail, and work out how the high-tech armor fits together. Drawing believable machines and equipment isn't always about being completely accurate—there's plenty of room for some creativity! Use regular patterns at key places to add realism to your mechanical invention and visual balance to your drawing.

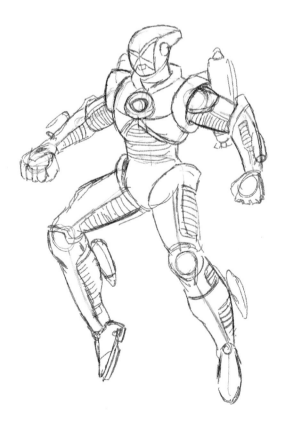

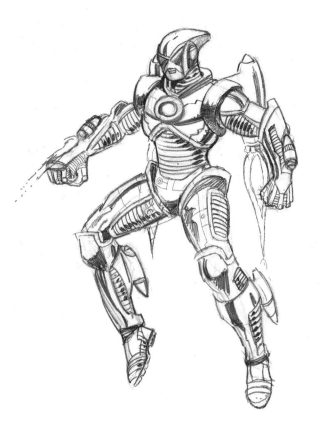

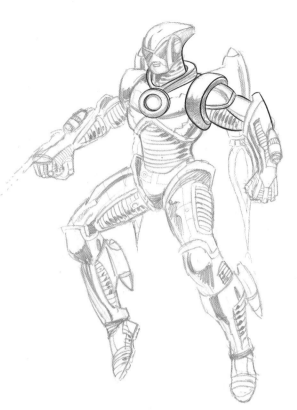

Step 4 Once you're happy with the basic details, finish rendering the drawing at the pencil stage. This allows you to preview how the shading will look, and you will get an idea of what areas will be tricky when it comes to inking, as well as which areas will need more detail (such as the abdomen).

Step 5 Now begin inking the drawing. (The pencil drawing is lightened here so you can follow along.) Use plenty of brushwork on this figure—even though he is mechanical—to create thick-to-thin lines that give the impression of mass, contour, and volume

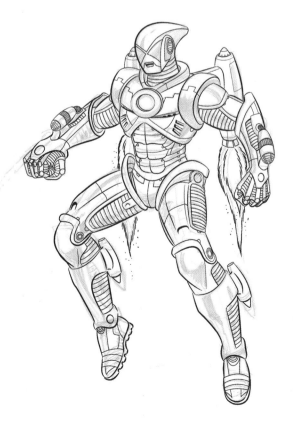

Step 6 Work around your drawing to keep the process fresh and fun. Tackle the abdomen armor, adding a lot more detail and using actual human musculature as your inspiration. Add details to the leg and chest armor that weren't in the original pencil drawing. Repeat the visual pattern of armor elements to give the suit a cohesive look. Notice how the segmented banding on the legs looks functional, but it also creates a pattern that helps the overall armor read as a costume.

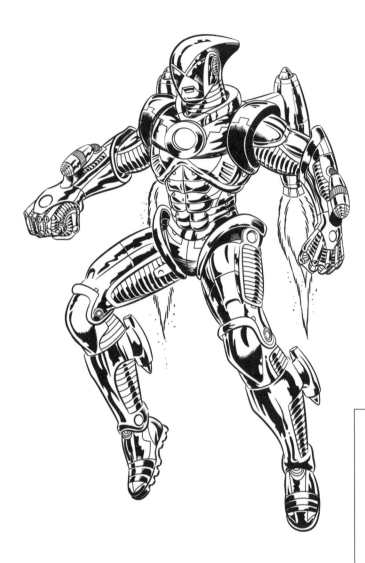

Step 7 In the real world, shine on metallic objects is a reflection of light and darker areas. In comics, we have to use shorthand that gives the viewer a visual cue that an object is shiny. High-contrast areas of squiggly black shapes are one of those tried-and-true conventions. But it isn't just about simply adding squiggly lines; draw in black shapes that also suggest shadow and form, especially around the shoulder joints, torso, and lower legs. Now the only thing left to do is add color!

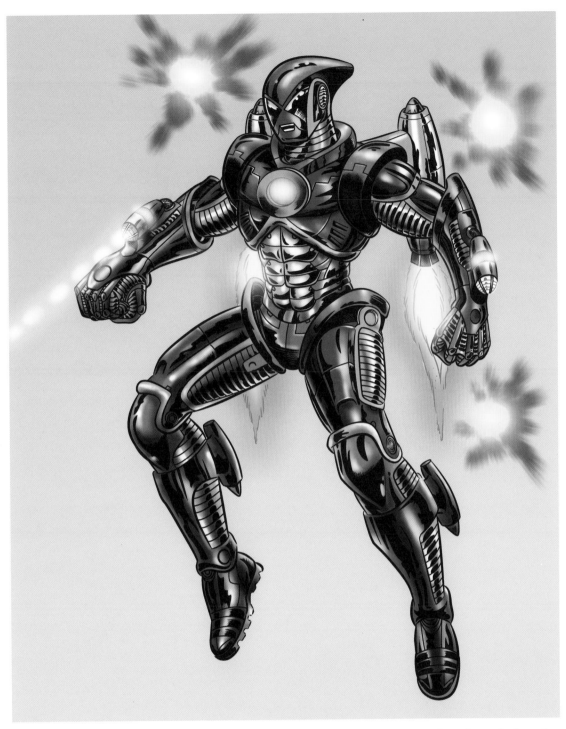

Step 8 Scan your inked drawing into Photoshop. First apply flat colors, and then add more dimension to the forms by adding color-modulated shading. Further enhance the metallic look by adding shine with the dodge and burn tools. Create a new layer for the blue sky, and add in explosive midair bursts from some unseen enemy. Our bionic hero hovers in midair, while his twin jet engines blaze away. His arm-mounted particle weapons return fire in a glow of electric blue haze.

ARTIST'S TIP

Take into account various light sources when you're coloring. In particular, notice the hot orange-yellow glow from the flames reflecting on the surface of the hero's armor. This kind of rendering not only adds drama to your art but also dimension and believability—and it just plain looks cool!

MegaGuy

Step 1 Start with a simple stick figure sketch, using a soft #2 pencil. Work freely and lightly; your drawing will take on more detail as you progress to each step.

Step 2 Rough in the muscle contours of the figure. Then loosely add rough details in the costume, such as his belt, boots, cape, and gloves. Begin to erase your initial sketch lines.

Step 3 Continue to add detail to the hero's belt and front of the costume, as well as the partial mask over his head. Add more anatomical details, defining the muscles in his arms and abs and shaping his fingers.

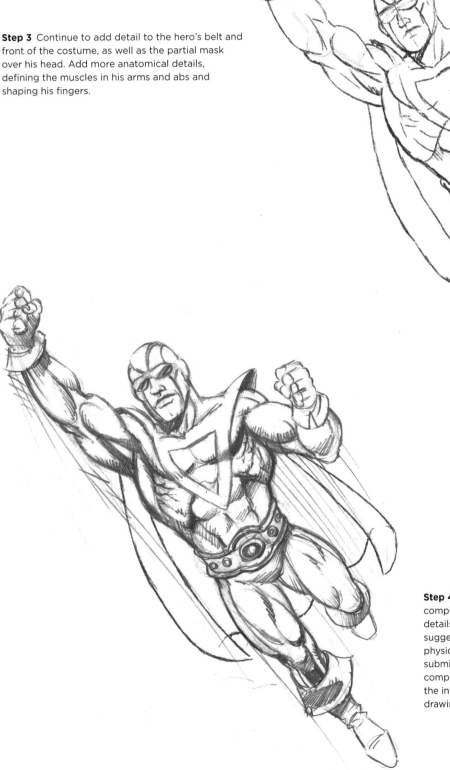

Step 4 Now that your initial sketch is complete, begin your final pencil. Work out details and lighting, using render lines to suggest the inner contours of the superhero's physique. Professional comic pencilers often submit a pencil drawing at this level of completion or greater. Now it is the job of the inker to polish the pencils into a tight ink drawing.

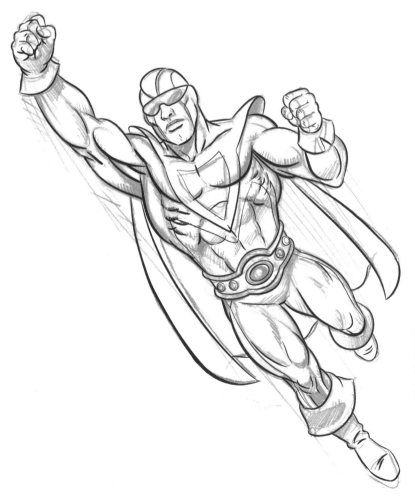

Step 5 Use India ink and a medium pointed round brush to start inking the outline of the figure. To avoid ink buildup, add a small amount of water to your ink. Keep your brush clean, and twirl it constantly to retain a nice point. For finer details or areas where you need more control, use a quill dip pen or a very fine waterproof marker with a soft nib. Think about where the light source is coming from, and try to vary the line to suggest areas that are facing toward the light and away from it. The light source for this drawing is coming from the upper right, so draw the lines on the lower left a little heavier to suggest shadow.

Step 6 Continue to ink your pencil drawing, refining the anatomy where necessary. Brushes work best on anatomical sections, but a pen is better on more "mechanical" objects, like his belt and goggles. You can freehand ellipse details on his belt or use templates to draw very clean ellipses.

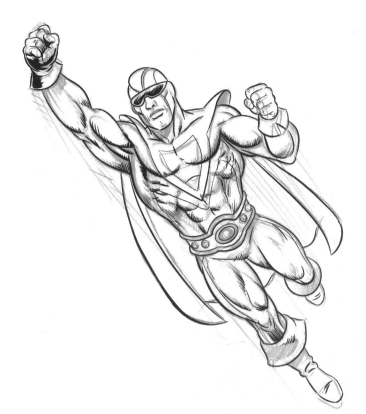

Step 7 Time to focus on the interior contours and details. Use feathered lines to start lining muscles and shadows. Note that the rendering is only used to clarify the drawing and make the transitions of form distinct. Feathering is difficult to master, so take plenty of practice strokes before making your final marks.

Step 8 Add solid areas of black to indicate the darkest shadows. These heavy blacks also give the image more graphic appeal. Then erase all the pencils lines, leaving only the finished ink drawing.

Step 9 There are many ways to color artwork for comics. Today the preferred method among professionals is digital coloring, using digital paint programs such as Photoshop. If you don't have this technology, a low-tech way to achieve similar results is to photocopy your inked drawing on a very good laser photocopier and use alcohol-based markers to color in your drawing. The alcohol-based pigments won't affect your photocopy, and most copy paper takes marker very well and allows for fairly even color distribution.

Lady Electric

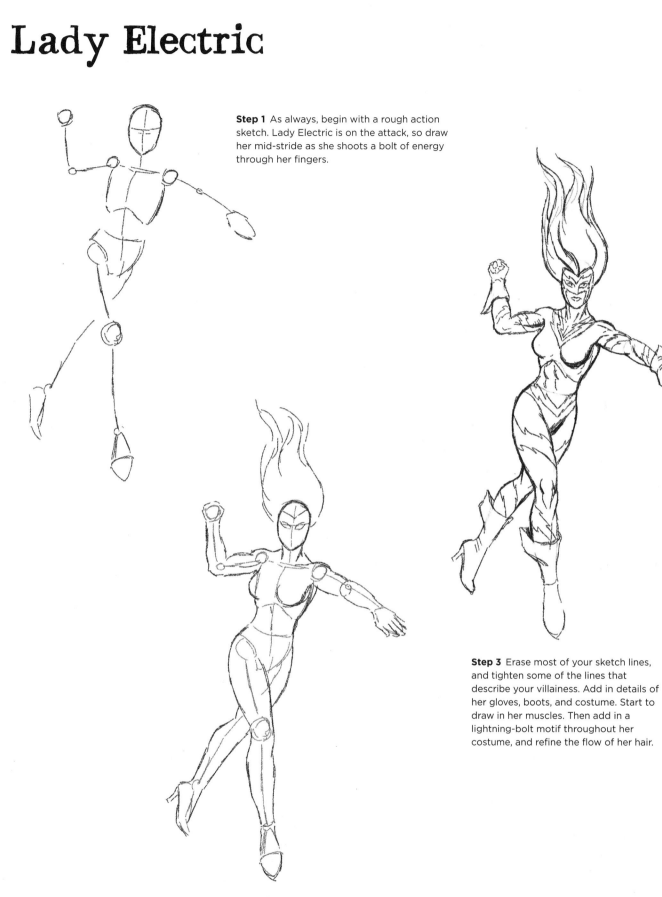

Step 1 As always, begin with a rough action sketch. Lady Electric is on the attack, so draw her mid-stride as she shoots a bolt of energy through her fingers.

Step 3 Erase most of your sketch lines, and tighten some of the lines that describe your villainess. Add in details of her gloves, boots, and costume. Start to draw in her muscles. Then add in a lightning-bolt motif throughout her costume, and refine the flow of her hair.

Step 2 Next begin to embellish, adding detail and refining her anatomy and pose. Because she is electrified, her hair stands straight up! Draw some lines suggesting the look of her mask and some details on her costume.

Step 4 Finish your pencil sketch by adding shading and other details. Her costume will have areas of full black to suggest shininess, so you can "preview" how you'll treat these areas by shading them in. This can be tricky and takes a little practice. The trick is to use enough black so that your reader sees her costume is dark and reflective, but keep enough of her anatomy apparent.

Step 5 Once you're satisfied with the pencil drawing and the areas of darkest value look like they'll work well, begin inking. (The drawing has been lightened here so you can easily follow along with the inking.) Lady Electric is very athletic and powerful, but you'll still want the outlines of her body to be smooth and flowing. Ink the longer lines of her body with a #2 brush loaded with a good amount of ink so the line flows well. The thick line on the outside of her right leg requires a couple of strokes.

Step 6 Lady Electric's hair has long, flowing lines that require a little extra care to ink well. Try a few practice strokes on a separate sheet of paper or illustration board first. Also ink in the electrical effect on her hands, and add some black streaks in her hair. Then add some black to her mask, and outline the bolt motif on her legs.

Step 7 Outline the black areas on the top of her costume with a pen first to give them a nice crisp edge. Then fill them in. You may wish to work differently, laying in your dark areas directly with your brush or a large marker for a more spontaneous look. Feel free to experiment and invent your own style! Finish the outline and solid-black areas on the bottom of the costume and her boots.

Step 8 Next crosshatch areas of her costume using an artist pen and a "dead" line. The tonality of the hatch work should be fairly regular, so use a steady line that doesn't have that thick-and-thin quality.

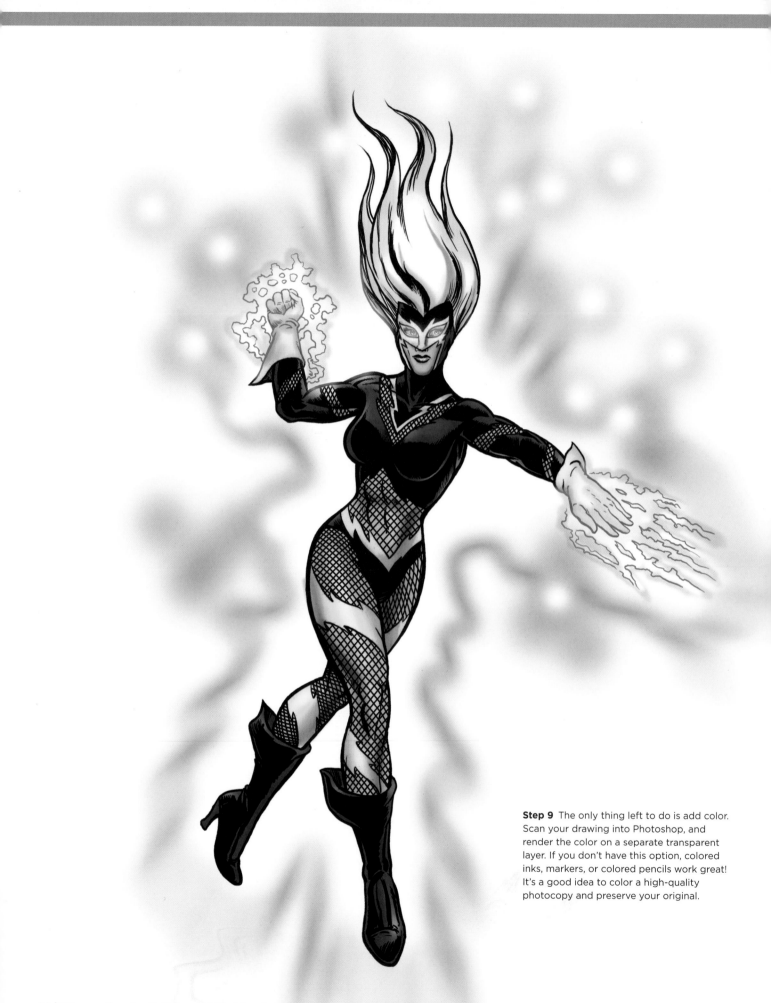

Step 9 The only thing left to do is add color. Scan your drawing into Photoshop, and render the color on a separate transparent layer. If you don't have this option, colored inks, markers, or colored pencils work great! It's a good idea to color a high-quality photocopy and preserve your original.

The Bulk

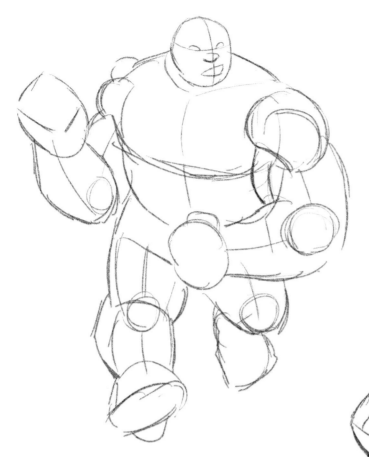

Step 1 Start by sketching out a rough version of his figure, using full shapes for his arm and his legs. Try to sketch him using large masses.

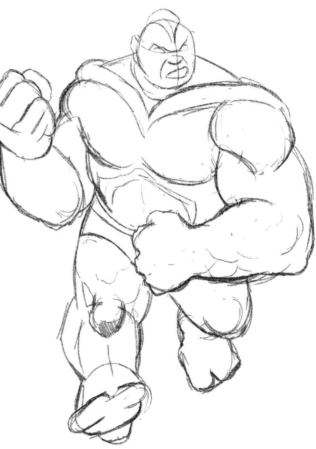

Step 2 Start sketching details of his anatomy, indicating some of his largest muscle groups and the structure of his armor-plated shoulders. Rough in the details of his head. Use an eraser to remove your sketch lines from step 1.

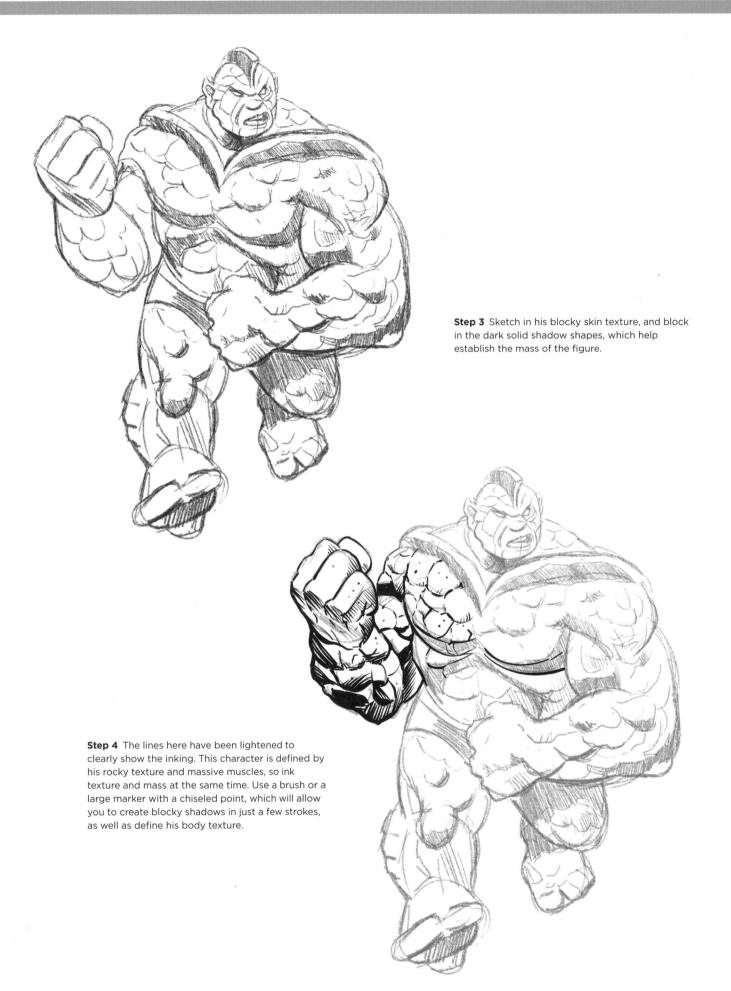

Step 3 Sketch in his blocky skin texture, and block in the dark solid shadow shapes, which help establish the mass of the figure.

Step 4 The lines here have been lightened to clearly show the inking. This character is defined by his rocky texture and massive muscles, so ink texture and mass at the same time. Use a brush or a large marker with a chiseled point, which will allow you to create blocky shadows in just a few strokes, as well as define his body texture.

Step 5 Block in the larger shadows to define his anatomy. Start adding a little rendering to the blocky skin texture. Working with line, shadow, and limited rendering is a balancing act, but you'll find you can render this character quickly, and he'll still appear very detailed. Make sure to leave enough white space so the detail of the creature's skin texture doesn't overpower the definition of his form.

Step 6 Work on the legs, using the same techniques to give them mass and texture.

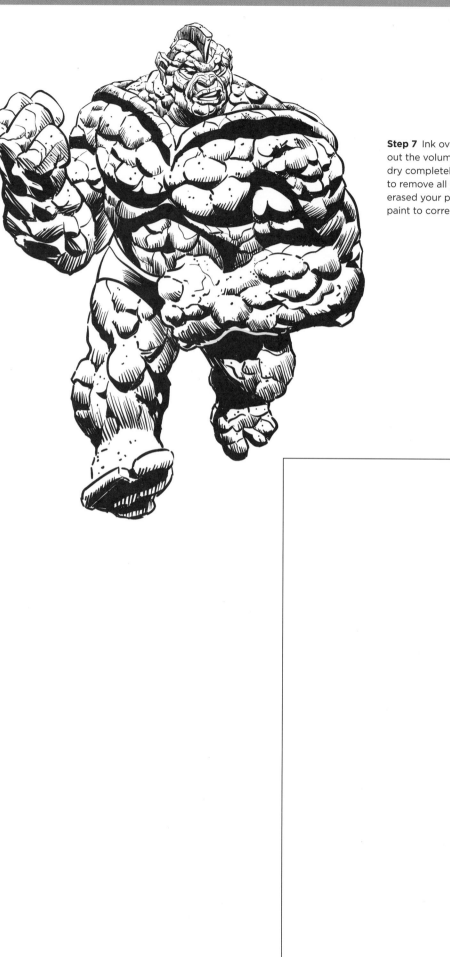

Step 7 Ink over the lines in the head to bring out the volume and texture. Allow the ink to dry completely, and then use a kneaded eraser to remove all your pencil lines. After you've erased your pencil drawing, you can use white paint to correct any mistakes.

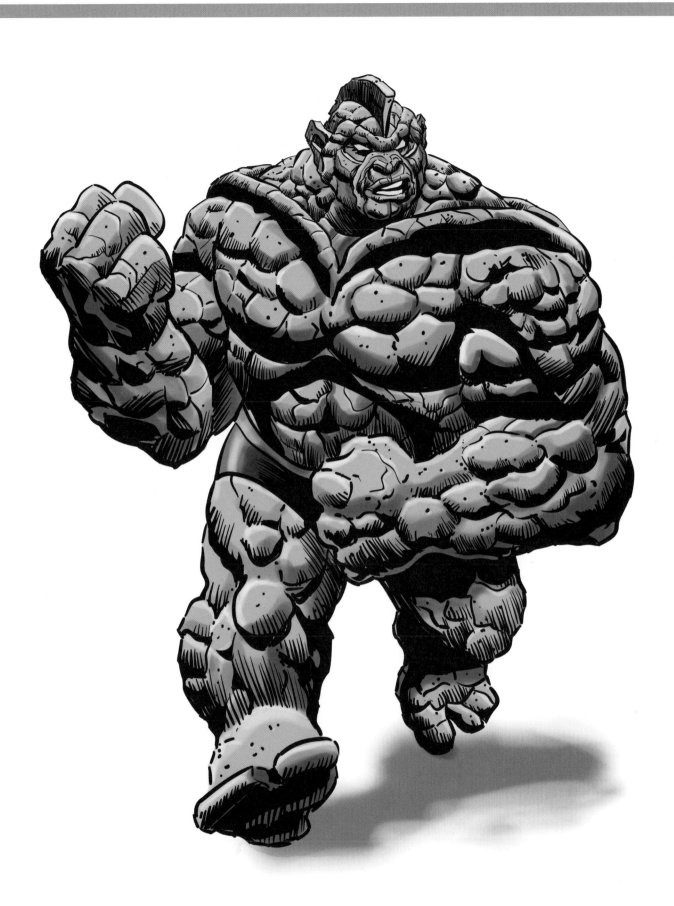

Step 8 Color in with blue. Then overlay a darker blue on the shadows to help further define his skin texture and form. Add highlights to the upper edges of the bumps on his skin. Now this creature is ready to clobber some bad guys!

Manga
Drawing Heads

The head is probably the most important body part to draw, as it is the source of a character's emotion and personality. Some artists draw in a more realistic style with facial proportions that are closer to the real human form; other artists choose to draw in a more stylized way with bigger eyes or longer foreheads. Once you understand the fundamental shapes and proportions of a typical realistic face and its features, you can bend the rules to create more extreme or unique styles.

Naturalistic

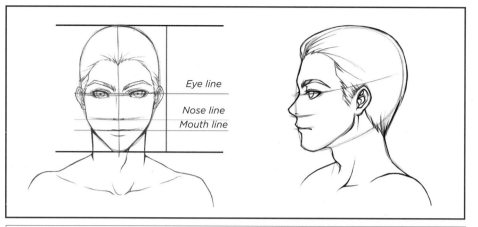

Stylized

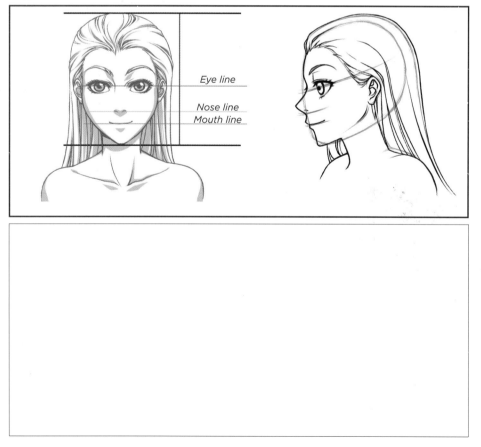

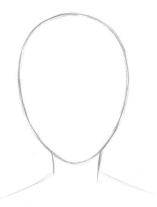

Step 1 To draw a head, begin with the head shape, which is usually an oval.

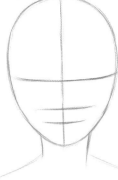

Step 2 Once you have established the face shape, sketch in the guidelines for the facial features—a cross for the eye line and T-zone and shorter horizontal lines for the nose and mouth locations.

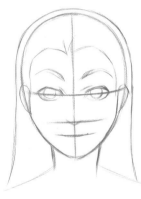

Step 3 Next lightly sketch the basic features—the eyes, ears, nose, mouth, eyebrows, and hairline. Try to sketch lightly, as darker lines are difficult to erase and may wear down the paper if you decide to redraw any features.

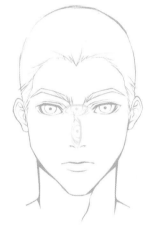

T-Zone A simple yet efficient way of measuring eye distance is to use the eye itself. Generally, the space between the eyes is about the length of one eye. There is a similar amount of space between the bridge and tip of the nose. However, these are only average measurements—your style may dictate otherwise!

Step 4 When you are satisfied with your sketch, ink your drawing, or turn it into line art. Add the final details, such as eyelashes and pupils. Some artists color directly on a refined sketch; others clean and tighten them with line art first.

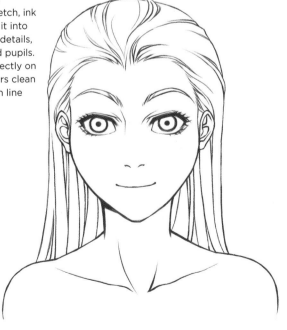

Drawing Hair

Curly, spiky, cropped, or straight, there are many different ways to draw hair, and hairdos can be interpreted differently based on an artist's style. Some artists prefer drawing hair realistically with a lot of detail. Others prefer a stylized look and draw only contour lines that imply the hair's shape. You can also block in the hair without highlights or shading if a character has dark hair. The choices are endless!

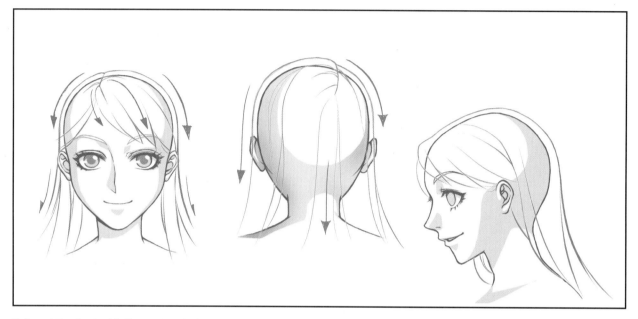

Hair and Gravity In this illustration, the hair is transparent so you can see how hair drapes around the head and neck. Keep in mind that gravity determines how a character's hair falls. Decide where you want to part the hair (this example shows a side part), and draw the hair hanging down from that part.

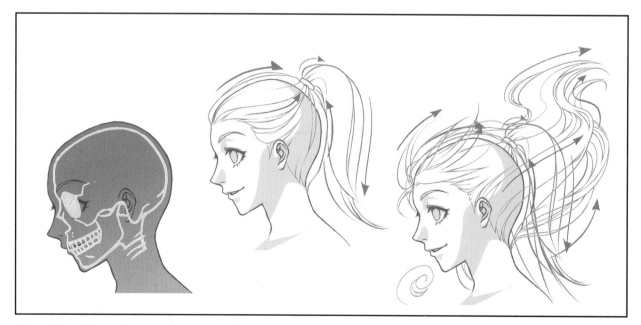

Hair and Head Shape There is a close relationship between the skull, head, and hair. The shape of the skull defines the head shape, and the head shape affects the size and direction of hair growth. Some characters have large hair styles or tie their hair back, and wind may influence the shape of hair. Always draw hair around the shape of the head and consider the effects of gravity.

HAIR TEXTURES

It is helpful to understand how individual strands and clumps of hair behave when trying to depict various hair textures and styles. Natural hair styles will have a different shape and weight than crimped, curled, or bluntly cut hair.

Manipulated Hair Imagine each strand of hair as a string. When straight, it is at its maximum length. Adding a wave, crimp, or curl shrinks the strand. Now remember that hair is made up of many individual strands.

Hair Ends In most styles, hair ends are drawn in points or clumps (below left). You also can draw hair that is cropped straight at the ends, giving the hair a freshly cut appearance (below right).

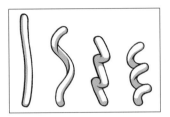

HEAD SHAPES

The shape of a character's head can reveal a lot about the character's personality. While the most common head shape is an oval, there are many other possibilities. The three basic shapes for drawing anything are the circle, square, and triangle. Experiment by combining the different shapes to create more unique and expressive head shapes.

Oval Most of your characters will have oval-shaped heads.

Triangular Sharply angled heads are good for evil villains.

Square Give strong, beefy guys sturdy, square heads.

Circular Comical characters often have circular heads.

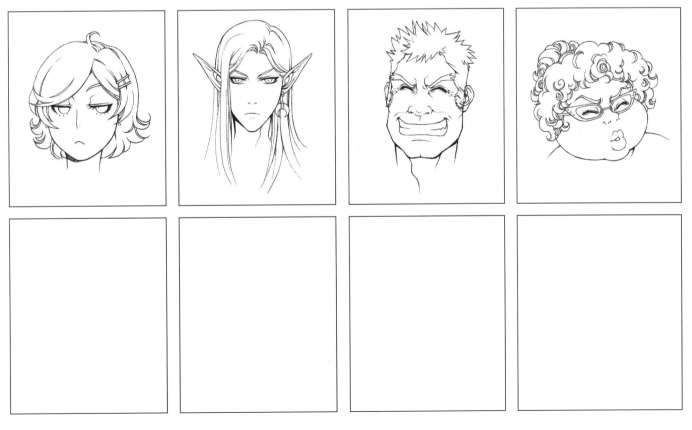

Drawing Facial Features

A great deal of manga storytelling occurs on a character's face, where a range of emotions are displayed. On page 36, you learned the basic proportions and relationships between features. Now let's focus on the individual facial features and see how they all work together to bring a character to life.

EYES

Eyes are easily the most expressive part of a character's face, and there are an infinite number of ways to draw them. Below are a couple of basic examples of different eye shapes and sizes. Notice how the eyes draw your attention and define the character. The male with beady, narrow eyes could be a villain, and the big, bubbly eyes on the right could belong to a young boy in a shōjo manga. Try experimenting with a few different eye styles while thinking about the type of character you are trying to portray. Factors such as age, ethnicity, and personality can all affect the eyes.

NOSES AND MOUTHS

Noses don't move the way mouths and eyes do, but they complete the overall symmetry of the face and add a bit of character. Some artists find it difficult to draw noses, especially from the front view, but sometimes it just takes two small dots, short lines, or the implied shadow of the nose. Also keep in mind that males tend to have more prominent noses. On the other hand, some artists don't draw noses at all. This is especially common in chibi drawings, where the nose plays a lesser role. The mouth is what makes a character smile, frown, laugh, or shout. Like eyes and noses, there are many ways to draw mouths—with simple lines or defined lips and dimples.

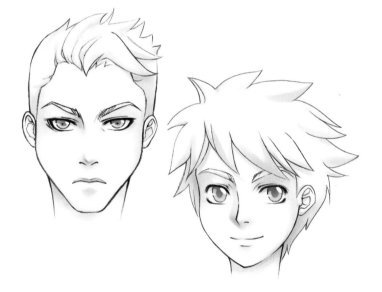

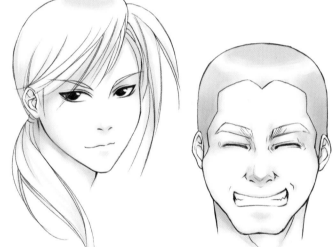

EYEBROWS

Eyebrows are also important for portraying expressions. Since eyebrows are made of hair, they will usually be the same color and style as a character's hair, although you can choose to give a little man huge bushy, black eyebrows. Altering the shape of the eyebrow is effective for showing emotions. For example, if both eyebrows are facing sharply toward the center of the face, that would make the character look very angry. Having them point up may give the feeling of surprise or shock. You can use your own face as a reference—get in front of a mirror and start making faces, and pay attention to how your eyebrows move and shift with each one.

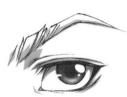

Angled Eyebrow

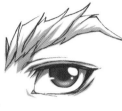

Bushy Eyebrow

Arched Eyebrow

Thin, Rounded Eyebrow

Realistic Eyebrow

Drawing Expressions Now put all of the facial features together to create different expressions. The character below is shown making a variety of extreme faces—happiness, sadness, embarrassment, disapproval, outrage, fear, and wickedness. Even though the expressions change, the character should remain clearly recognizable in all drawings with consistent features, or readers may confuse him/her for different characters. A great exercise is to draw one character with many different emotions, making sure that he/she looks like the same character throughout.

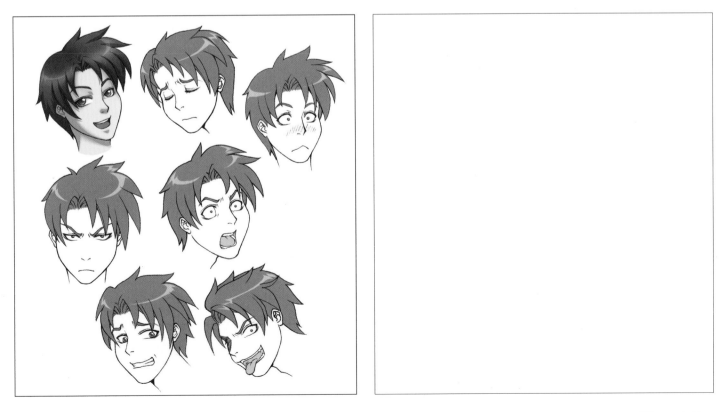

Character Development

Now that we've covered a wide range of fundamentals about creating manga characters, it's time to get into the technical details. When you're ready to design a manga character, start by making a turnaround sheet. A turnaround sheet, also called a "character turnaround," is a composition of drawings of a character from specific angles. Character turnarounds help you draw a character accurately from multiple angles and act as your go-to source for your character design. This is where you do all of your conceptualizing and brainstorming on what your character looks like.

Step 1: Guidelines The four main angles on a turnaround are FRONT, QUARTER (3/4), PROFILE (SIDE), and BACK. Draw horizontal guidelines to help you keep the proportions on track as you draw each angle. The blue lines in this turnaround indicate the top of the head, bottom of the chin, waistline, bottom of the crotch, knees, and bottom of the feet. You can add or remove lines, depending on what is helpful for you. Next draw guidelines for the character's pose in each angle. Use straight lines to indicate body parts and circles to indicate joints.

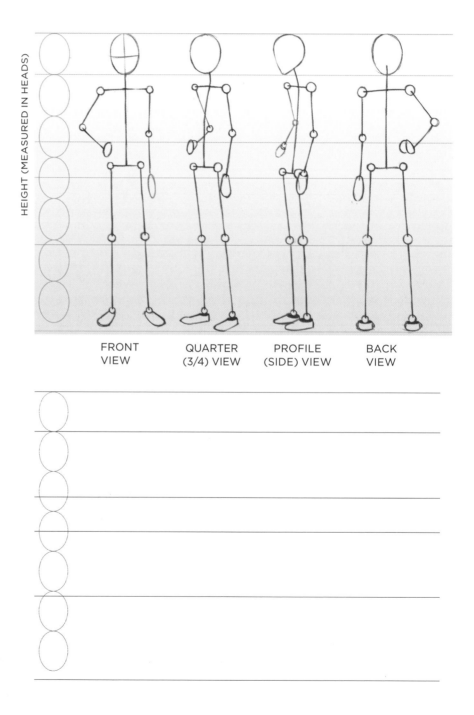

HEIGHT (MEASURED IN HEADS)

FRONT VIEW QUARTER (3/4) VIEW PROFILE (SIDE) VIEW BACK VIEW

Step 2: Basic Shapes Next, use basic shapes to "flesh out" your character's body parts. Circles, cylinders, and squares are simple shapes that are easy to identify and envision, so try using those first. Add a crossed horizontal and vertical line on the face to indicate the facial features.

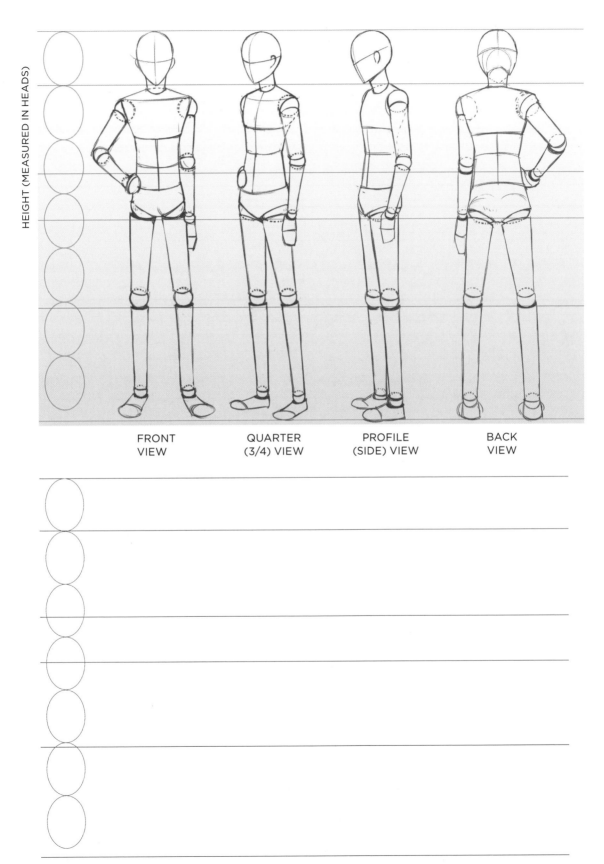

HEIGHT (MEASURED IN HEADS)

FRONT VIEW QUARTER (3/4) VIEW PROFILE (SIDE) VIEW BACK VIEW

Step 3: Body Sketch Next, follow the basic shapes to draw your character's body from each angle, without clothes. Some artists skip this step, but it can helpful, especially in trying to keep body proportions accurate. Drawing the body underneath gives you something to "wrap" clothes around. Start drawing in the basic facial features and hairstyle too!

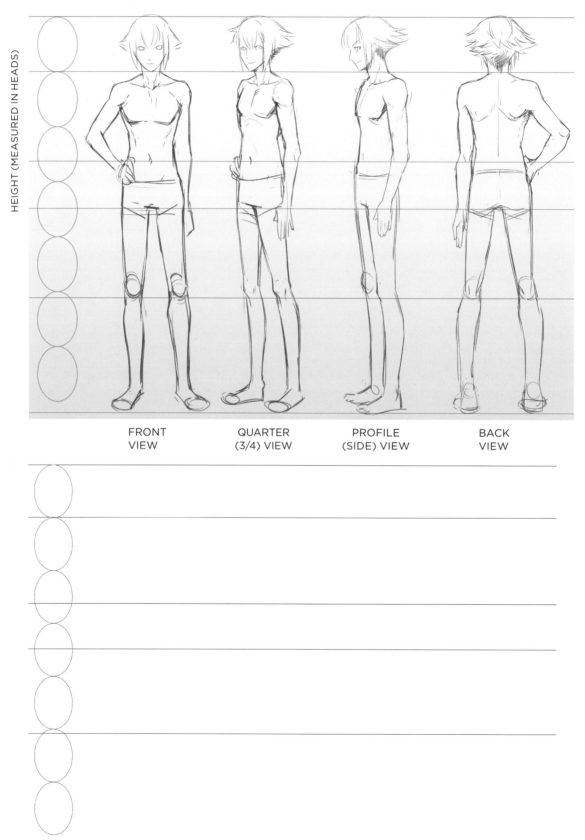

HEIGHT (MEASURED IN HEADS)

FRONT
VIEW

QUARTER
(3/4) VIEW

PROFILE
(SIDE) VIEW

BACK
VIEW

Step 4: Detailed Sketch Using your body sketches as a guideline, fine-tune the details. Draw your character's clothes, accessories, hairstyle, and any other character quirks. Focus on details, and work out all the kinks. This is the last step before inking and coloring. If you want to change something, this is the time to do it!

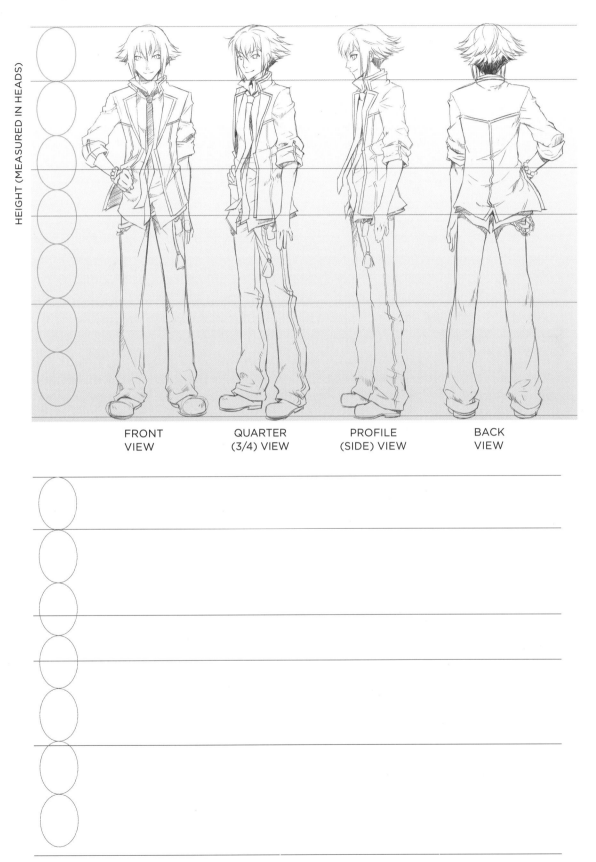

HEIGHT (MEASURED IN HEADS)

FRONT VIEW QUARTER (3/4) VIEW PROFILE (SIDE) VIEW BACK VIEW

Step 5: Line Art In this step, finalize your sketches by inking them, either traditionally or digitally. Inking grounds the image and allows you to clean up and refine sketches.

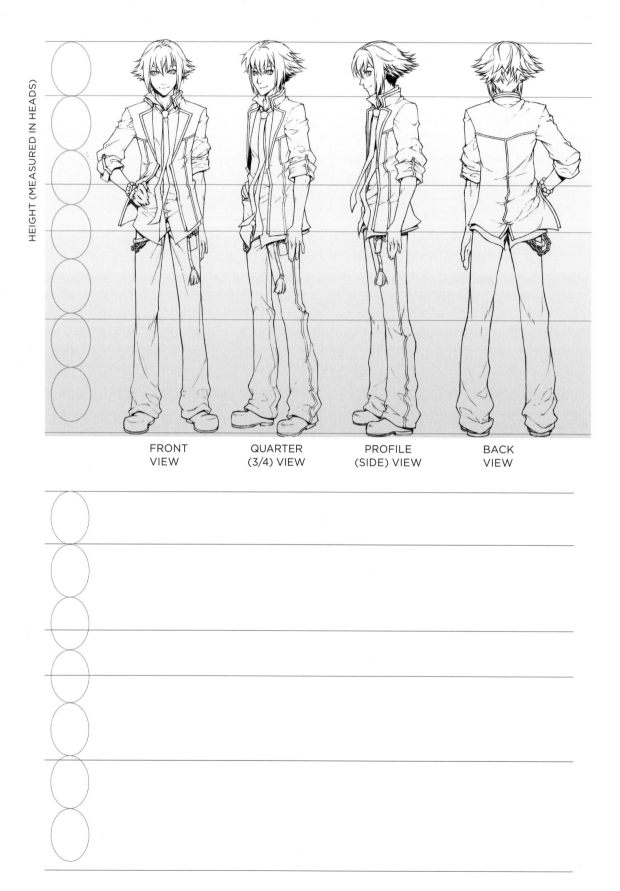

HEIGHT (MEASURED IN HEADS)

FRONT VIEW QUARTER (3/4) VIEW PROFILE (SIDE) VIEW BACK VIEW

Our Hero

Most manga adventures feature a mysterious and moody hero with a serious but honorable goal or quest. This male hero may appear cold and distant, but he embodies the values of perseverance, fellowship, and justice.

Step 1 Block in the basic shapes, and map out the line of action, hip and shoulder lines, and major joints. Finalize the pose, body proportions, foreshortening, and perspective at this stage to prevent troublesome revisions later on.

Step 2 Sketch the basic contours of the body and sword. Developing the body will help with clothing shapes and folds later. Working from the head down, add basic details in the hair, face, hands, and feet.

Step 3 Now add the clothes, but sketch lightly, as hard lines are difficult to erase and tend to smudge. Work in layers, drawing the shirt, coat, and pants. Next add accessories, such as the tie, pocket chain, and shoes.

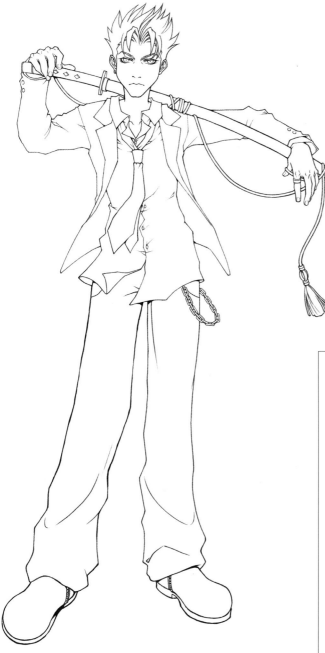

Step 4 Once you have your final sketch, you can ink your drawing to create line art or make it more permanent. Inking will force you to clean up your drawing, making it easier to scan or color over.

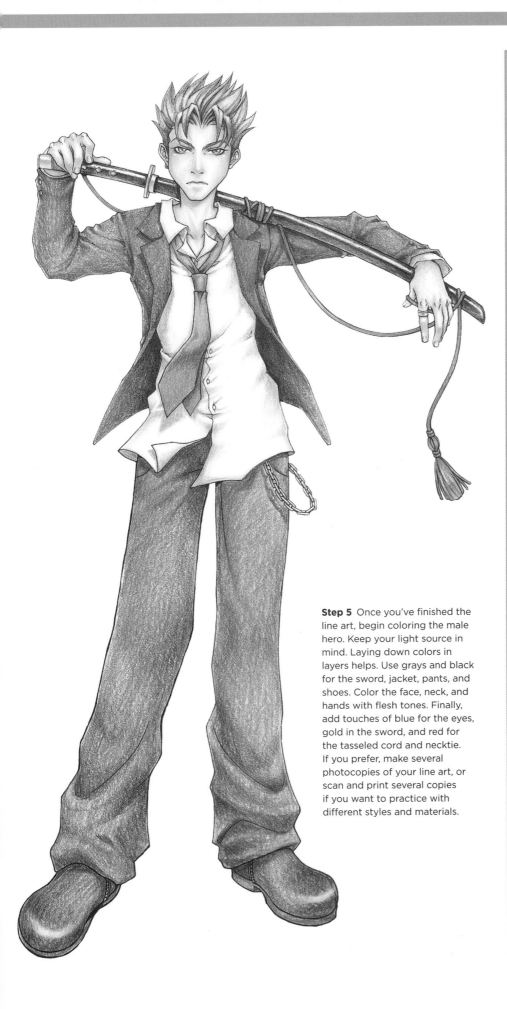

FINISHING TECHNIQUES

Fine details and value contrasts can bring a character to life. Not all of the details have to be drawn in the line art; shapes, depth, and details can be rendered with coloring.

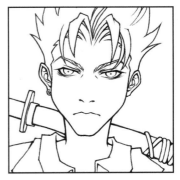

Details In the line art, the major details have been drawn in, but the nose is only represented with nostrils.

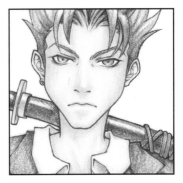

Layers Color in layers, starting with the lightest colors and gradually building up darker colors.

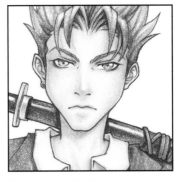

Shadows and Highlights Create sharper contrasts by darkening shadows and brightening highlights.

Step 5 Once you've finished the line art, begin coloring the male hero. Keep your light source in mind. Laying down colors in layers helps. Use grays and black for the sword, jacket, pants, and shoes. Color the face, neck, and hands with flesh tones. Finally, add touches of blue for the eyes, gold in the sword, and red for the tasseled cord and necktie. If you prefer, make several photocopies of your line art, or scan and print several copies if you want to practice with different styles and materials.

Schoolgirl

Shōjo manga often revolve around the daily lives of junior high or high school students. This schoolgirl's main concerns involve passing her classes, finding romance, and bonding with her girlfriends. She may have hidden superpowers, but that's for you, the mangaka, to decide!

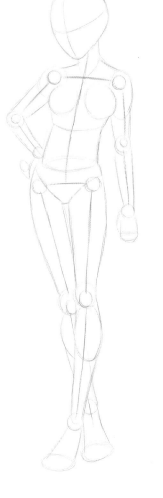

Step 1 First, sketch out the basic shapes for this casual pose. Be sure to establish the action, shoulder, and hip lines; place the major joints; and measure out accurate body proportions.

Step 2 Draw the basic contours of the body, hair, and handbag. Next add her facial features. Think about the character's personality. This classic "girl next door" has straight hair and wide, innocent eyes.

Step 3 Now draw her clothing. A traditional Japanese school uniform includes a collared shirt, tie, sweater, and short pleated skirt. To complete the outfit, add accessories, such as hairpins, a watch, plush keychain, and shoes. Be sure to render your final details and textures at this stage.

Step 4 Ink the sketch, and erase unnecessary marks. Use fine, thin lines for a light, cheerful mood. You may want to make copies of your inked drawing to practice coloring on and work out your color palette before applying color to your line art.

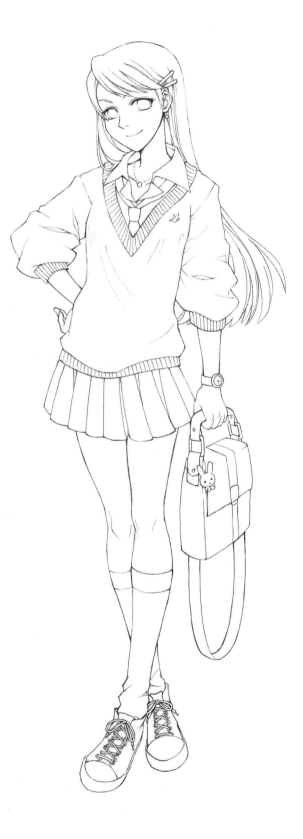

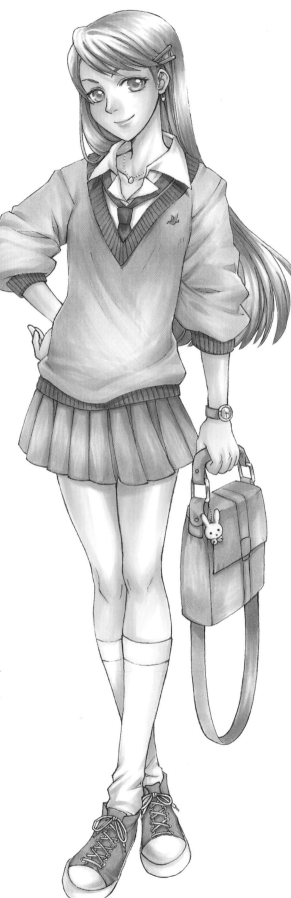

Step 5 Begin coloring by laying down the lightest colors first, and then build up the darkest areas. If you are working with markers, use light pressure. Try using a cool gray for the sweater and a warmer gray or brown for the bag. With soft strokes, capture the textures in the blue skirt and strands of brown hair. Color the tie red, and add pink for the hairpins, watchband, and shoes. Finish up by adding a few key highlights with a white gel pen or white acrylic paint. Adding white dots to the eyes and jewelry make them look brighter and shinier.

Comic Relief

Almost every story has a comedic-relief character. Comedic-relief characters are generally "lighter" and tend to crack the jokes or have a goofier role in a story. This character is intelligent but shy, especially around the ladies. And he's never too far from a book or computer. He may think he's a social failure, but deep down he has a kind and sincere heart that everyone loves.

Step 1 After drawing the guidelines and basic shapes, work on the body contours. This geek character has a thick, stocky build.

Step 2 Draw in the uniform, shoes, and hair. Remember to use the body sketch as a guide as you "wrap" the clothes around him. Add thick, rectangular eyeglasses as an accessory.

Step 3 Once you have the clothing down, build on it and add more detail. Start by adding buttons to his sleeves and tailoring lines to his coat and trousers. Finally, add a shoulder bag to give him a studious, bookworm-type look.

Step 4 Once all of your line art is complete, lay down the flats. Remember: flats are the most prominent color of an area. The flats should give you a general idea of what the final colored piece will look like.

Step 5 Next, add some basic shading. Remember to first select your light source! In this case, the light source is from the top center. Try to see where the darkest areas will be, based on the light source: under his arms and after the bend of his knees. Move from section to section, selecting a basic shading color that matches each flat color and adding some rendering.

Now select darker colors, and add another layer of shading to push the shapes and add more dimension. Then select colors that are lighter than those used above, and add highlights to bring in more depth and dimension.

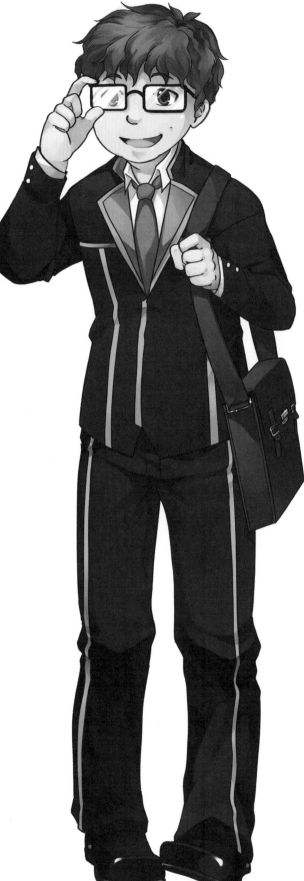

Step 6 Lastly, add some subtle highlights to add a nice level of finish. Add some bright-white highlights to his eyeballs, followed by some dramatic glare on his eyeglasses. Then add some highlights to the metal parts on his shoulder bag. Finally, add some nice white gleam spots to his shoes to make them look shiny.

Finished! Our kind-hearted support character is ready to tackle whatever lies ahead.

Zaim

Now that we've covered our protagonist and heroine, it's time for our villains! Conceptualizing was really important during Zaim's character development because he has so many iconic details: horns, special eyes, a gauntlet on one hand, and wings.

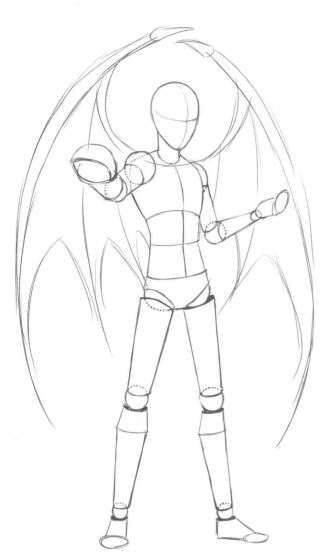

Step 1 Begin by sketching guidelines and drawing shapes. Pay special attention to the foreshortening of his right arm in this stage, and try to get the correct proportions. Sketch in the wings as well.

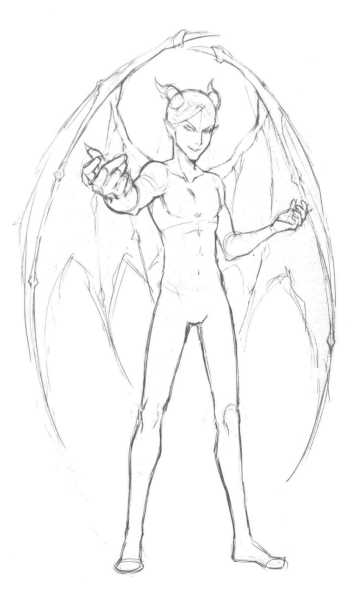

Step 2 Using the basic shapes as a guide, draw the contours of Zaim's body, working out his muscle structure. Sketch in his face, horns, and fingers. Add a little more structural detail to his wings.

Step 3 Once the body is done, sketch in his clothes. Simple, rough lines are fine right now, as you will hone in on the details later. In this step, determine all the folds and creases of the clothing. Refine his facial features a bit more, and draw in his hair.

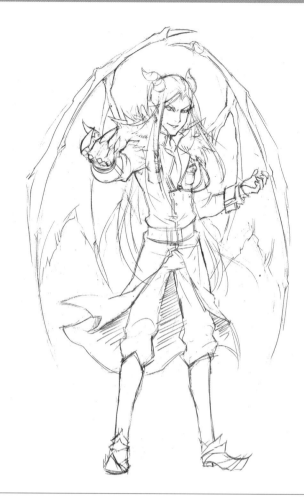

Step 4 Clean up your sketch, and erase any unnecessary lines. Add final details in the accessories, clothing, and hair. Then ink over your lines. It's okay to change your mind as you ink and alter some of the lines.

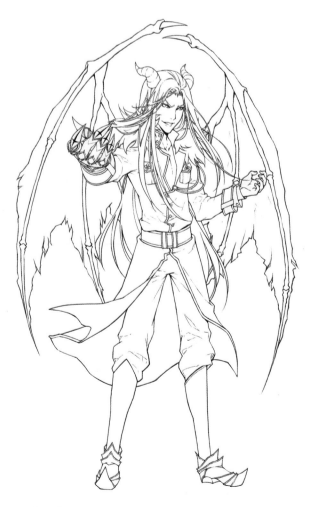

Step 5 After scanning your art, separate the line art on its own layer, and make sure it's transparent. Then add flat colors underneath the line art on a separate layer.

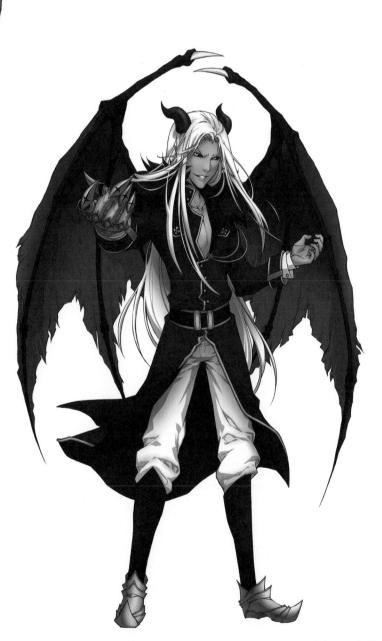

Step 6 Create a new layer on top of the flats but underneath the line art, and set it to "Multiply." This is the layer for the first level of rendering. Use one solid color, and add cel-shading, tackling one area at a time. Start with the face, move to the hair, and then slowly work down the body. Shift the rendering on the skin to a slightly redder color to match his base skin tone. Change the rendering on the white fabric on his clothes to a neutral shade. Use airbrushing and color gradation effects on certain areas to achieve a "hybrid" cel-shading airbrushed look.

Step 7 Now for the final touches. Add highlights to his wings and the metal and gemstones of his demonic hand. Add a blue-tinted gradation layer on the bottom of his coat so that it changes from purple to blue as it goes down. Because Zaim's clothing is mostly dark, many of the details and edges get lost and bleed into each other. To make these areas "pop out," add subtle reflect light to the edges to break up the dark areas. Adding reflect light to edges lost in shadows brings them back to view and adds depth. Finally, add a yellow glow to his eyes and glowing red airbrush strokes to the gemstones on his hand to add a sense of movement.

Character Interaction

Character interaction is important if you plan on making your own manga. For this project, you'll draw a demon brother and his younger sister, who both serve under Zaim. The older brother loves to tease his younger sister and particularly likes to steal any of the delectable human treats she brings back from her excursions to Earth!

Step 1 Refer to the thumbnail sketch as you draw the guidelines for these characters.

Step 2 After drawing the basic shapes, draw in the contours of both bodies. Step back from your sketch once in a while, and observe it from a distance. You may notice mistakes that aren't so obvious when staring at it up close.

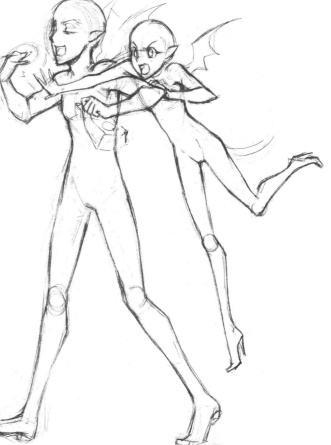

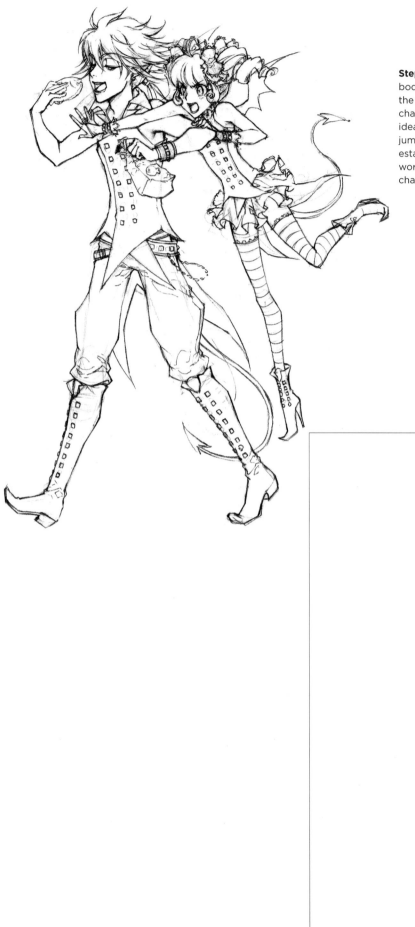

Step 3 Layer clothing and accessories over the body sketch for both characters. Then sketch in the details for their hair. Since there are two characters, focus on one area at a time. It's a good idea to start and finish one character rather than jumping back and forth. This way you can establish one character as the "foundation" and work the other character around the first character's position.

Step 4 Ink over the drawing. Then spend some time trying out different color combinations and filling in your color flats.

Step 5 Create a new layer over the flats layer in Photoshop, and name it "cel-shading." Set the layer to "Multiply," and select a gray-purple color as your foreground color. Using the lasso tool (you can also use the brush tool), add basic cel-shading to your drawing. Because you have the layer set on "Multiply," you can do all of this without having to change colors for each area, or to swap layers.

Step 6 Using your flats as a guide, render and blend in the brother's skin, as well as both siblings' tails and wings. You can turn off the other layers and work on one layer at a time. It's a good idea to work on the biggest parts first and then focus on the smaller details.

Step 7 After you finish rendering each section, turn on all the layers so you can see everything together and check for errors. Make sure the light source is consistent and that the details align properly across the sections. Adjust the color in a few areas as you see fit, using the "Hue/Shift" tool in Photoshop. Then use the dodge and burn tools to brighten and darken areas to add depth.

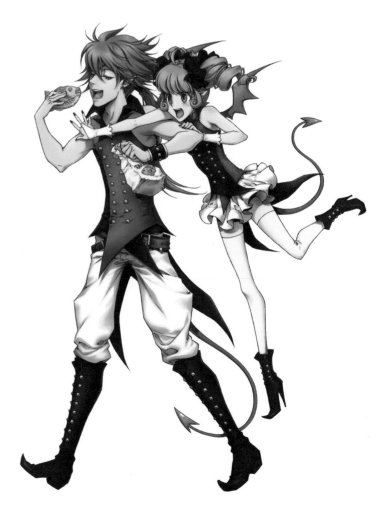

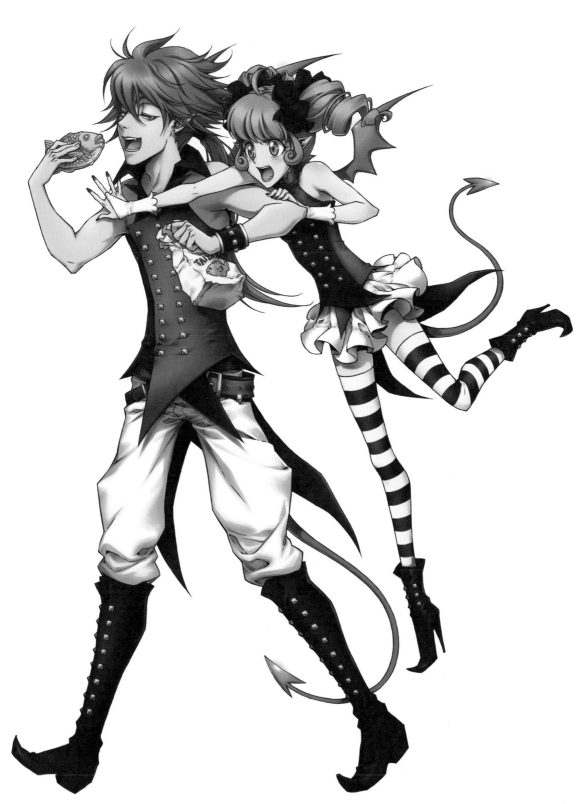

Step 8 Make a new layer to add stripes to the sister's stockings. Set the layer to "Multiply," and use a dark gray for the stripes so that the texture of the white parts shows through. Finally, add white gleams to both siblings' eyes and glows to their buttons and the brother's earring and belt buckle. Then add reflected light along some of the dark edges to make the details "pop."

Science Fiction
Robot Attack Pod

Small, agile, heavily armed, and expendable robotic sentries with full artificial intelligence are inevitable for future war and guard duty. As for design, functionality is key. The robot must be able to detect an enemy, so it needs some obvious detection devices like cameras and ocular-looking gear. It also must have some way of dispatching combatants and protecting itself, so it needs lots of armor and weapons. Finally, it needs to look intimidating. The best deterrent is to scare off the opposition before firing the first shot.

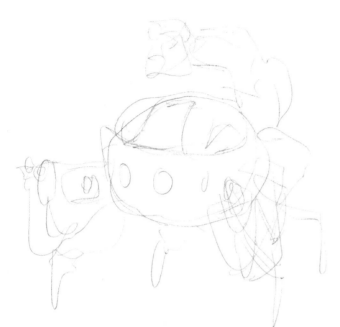

Step 1 Use a 2H pencil to lightly gesture the shape and position of the main body and extremities.

Step 2 Start to draw the perspective of the fat cylinder that is the "body," as it will dictate the forms connected to it. Draw through the forms to be sure that the structures are sound, and lay in other forms based on that grid of structure.

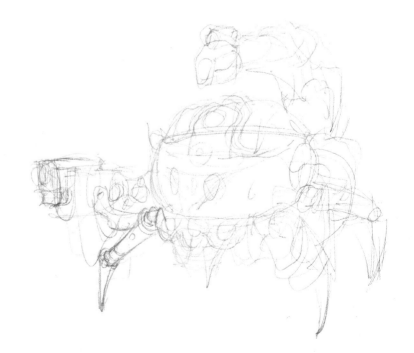

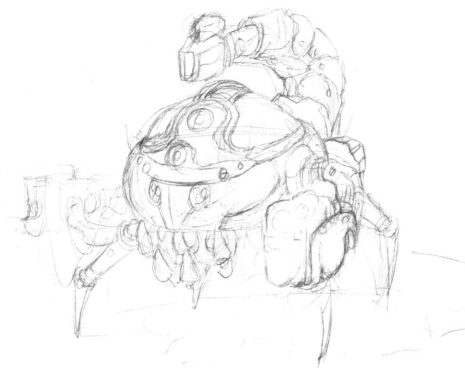

Step 3 Give the robot a face (made of machinery, of course), develop the weapons, and begin adding other details.

Step 4 Start developing the arm that's farthest from the viewer; then add some shadow edges to the armor on the tail as well as some more structural detail to make it look more like a weapon. Begin to lay down final lines on the body.

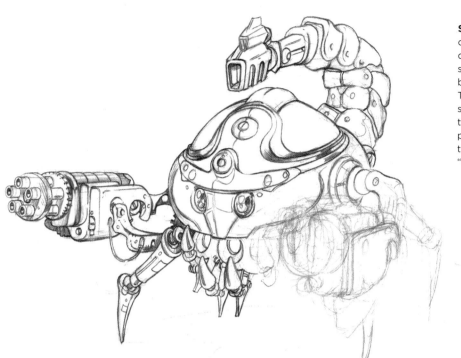

Step 5 Try out a few things with the closest arm, and use an HB pencil to develop the rest of the creature, making sure the forms have structure and adding blacks where you can to separate forms. The gun in the farthest arm has some strong cylindrical shapes, so use ellipse templates to make sure the forms are precise. Once the major forms are in place, the rest of the shapes are simply drawn "on top" to reinforce the main form.

Step 6 Now address the closest arm. Darken the rest of the lines, and make the details a bit more heavy-duty.

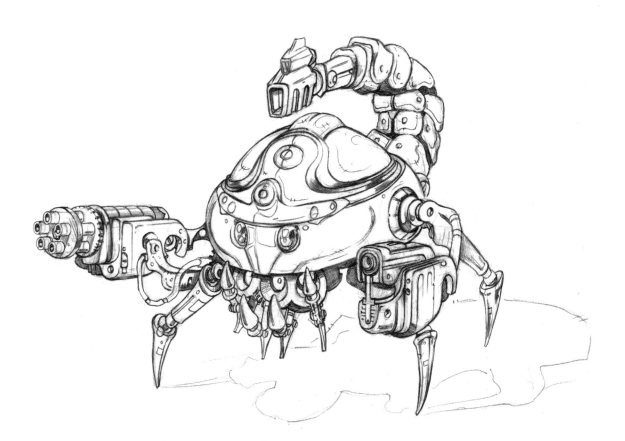

Step 7 Now use the HB to finish the details surrounding the closest arm, fill in dark areas, and add more thick and thin lines to solidify the forms.

Brain in a Jar

A brain in a jar is a standard mad scientist prop. For some reason, brains stuck in jars eventually turn evil (more so if it's a Brain from Outer Space). But if you're a brain in a jar, do you really have anything better to do than to think evil thoughts? A brain that is detached from a body, yet still able to think and perhaps (with mechanical or minion aid) act upon those thoughts is a danger to all.

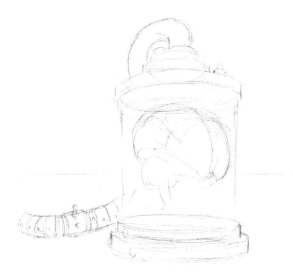

Step 1 With a 2H pencil, lightly sketch the pose. Draw the horizon line and ellipses on the top and bottom of the jar; then loosely sketch the general shape of the brain inside the jar. Next tighten up the major structures of the jar. Then add a tube coming out of the top of the jar for the technological element.

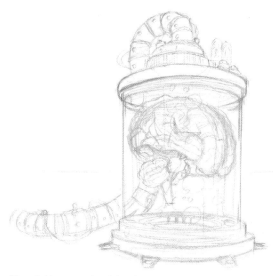

Step 2 Now use the side of your pencil to develop the brain further, making sure it reflects the anatomy of a real brain.

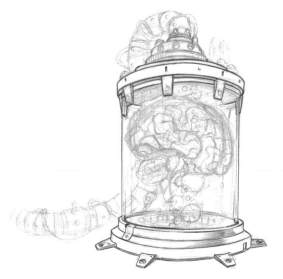

Step 3 Continue adding details, mostly paying attention to the folds of the brain. Even if it looks like chaos, there's a rhythm to it. For the brain to look convincing, it's important to get the general idea of how the folds work. Add details to the jar, and draw some bubbles surrounding the brain. Next switch to a 2B to finalize the lines, starting from the outside and working your way in.

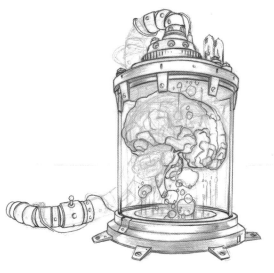

Step 4 Return to the 2H pencil to add a few shadows in the metal, and switch to the 2B to darken the brain. Outline everything you can, and start thinking about where to place shadows.

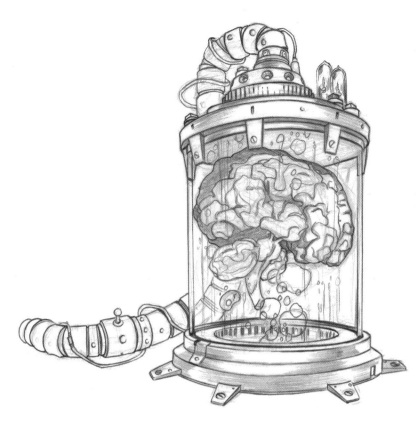

Step 5 After outlining the brain, go back in to add shadows and darken areas that will be in shadow or that will help accentuate the forms.

Starfighter Pilot

Ever since the invention of the Flying Ace during World War I, people have been fascinated with flying warriors. When extending this idea to future battles in space, we get the Starfighter Pilot. This character has the ability to think quickly, is tough in the face of extreme G-forces, and has a bit of an addiction to adrenaline.

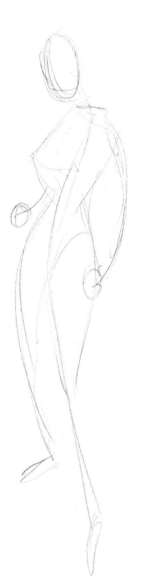

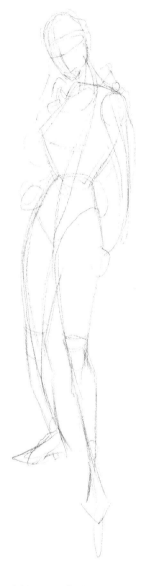

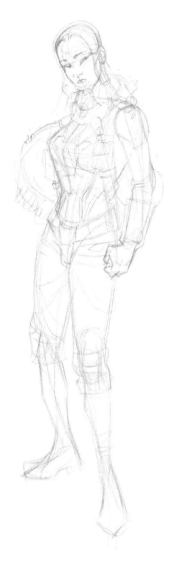

Step 1 Use a 2H pencil to lightly sketch the pose. The head is cocked, and the line of action shows the hips pushing forward and the shoulders leaning back.

Step 2 Now use the basic cylinder, ellipse, and cube shapes for the forms of the body and the large costume elements. The placement of the arms and feet are very specific to the attitude, so make sure they are working here before you get too far along.

Step 3 Still working lightly, draw the costume around the core of the body and head, starting with larger shapes and working out to the arms and legs. Next work up a facial expression that complements the pose: tough and confident.

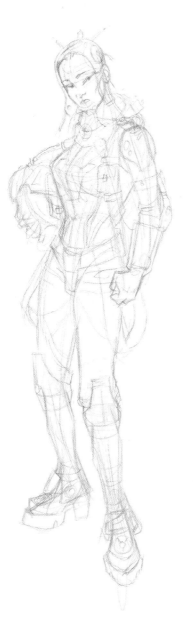

Step 4 After you finish the core elements, add details and the movement of the costume. Since the figure is wearing a uniform, give the jacket more structure while retaining the female form underneath. Suggest a great deal of metal and wires and tubes that attach to the ship and monitor her vital signs.

Step 5 Now use the HB pencil to start laying in the final lines, beginning with the head. Focus mainly on outlining forms and defining planes and edges at this point. A lot of the forms are overlapping, so you need to draw through forms.

Step 6 Continue placing outlines and planes with the HB pencil. The folds and wrinkles in the fabric are a great way to describe form. Make sure that the lines not only radiate from points of tension but also wrap around the form of the body.

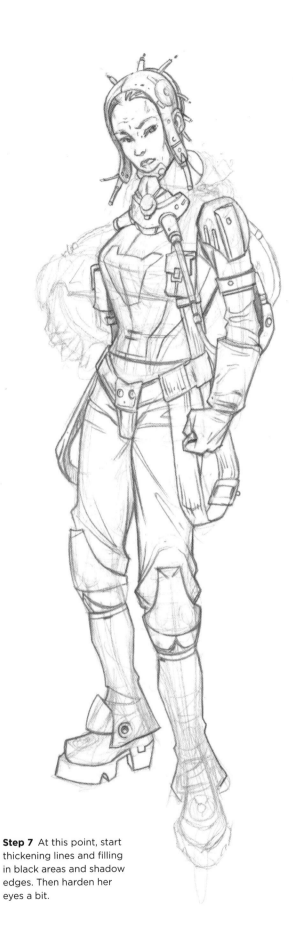

Step 7 At this point, start thickening lines and filling in black areas and shadow edges. Then harden her eyes a bit.

Gray Alien

Alien abductions have been actively chronicled since the 1960s, but accounts of interactions between humans and aliens go back as far as the nineteenth century. The classic gray alien is often described with striking similarities by abductees and witnesses from all over the world. Whether this is due to mass hallucination or people conforming to popular images, the gray alien makes a great antagonist to any space hero.

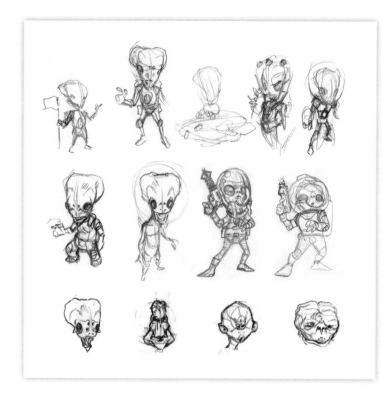

Concept Sketches Small thumbnail drawings will help you warm up and keep you from falling into visual clichés. They also allow you to experiment with the character's attitude, costume, and props. Try fitting the heads into circles, squares, or even hearts and stars—the results will enhance your final drawing.

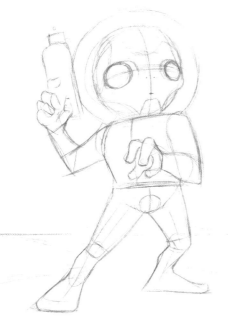

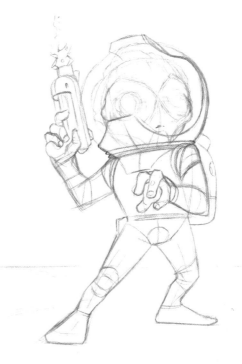

Step 1 Using a 2H pencil, start with a few quick lines to establish the general shape and gesture of the figure. Then refine the shapes, adding centerlines to the basic forms. Place a horizon line, as it's important to know where the viewer's eye level is. Place this horizon line low on the page to make the diminutive character more imposing. Next draw some ellipses around the brow line, waist, shoulders, and knees. To exaggerate the pose, make the alien's right shoulder a bit lower than his left. Next add the fingers and the ray gun, being sure to draw through shapes to ensure that they make sense.

Step 2 Now start developing the alien's spacesuit, making sure to follow the form of the alien's body.

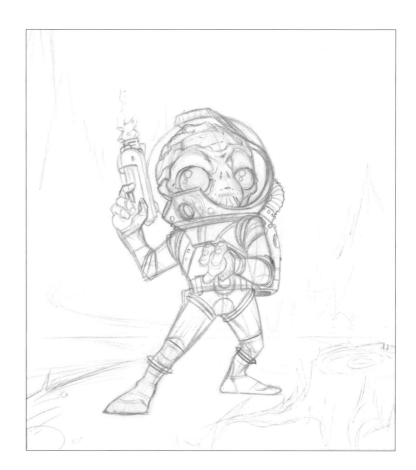

Step 3 The alien's large head is a main feature of this drawing, so start adding details and filling out the form. Create large, glassy eyes, developing the ocular cavities accordingly. Add some costume detail, such as rivets. Next work on the alien's environment to give him some context. Imagine he's just landed at the edge of a forest in a lightly populated area. Lightly sketch a tree stump, some grass, a tree line, and a large oval to represent the start of a flying saucer. The top of the stump is below the horizon line, so you can see a slightly open oval shape for the top plane. Draw the bark so that it wraps around the cylindrical shape of the stump.

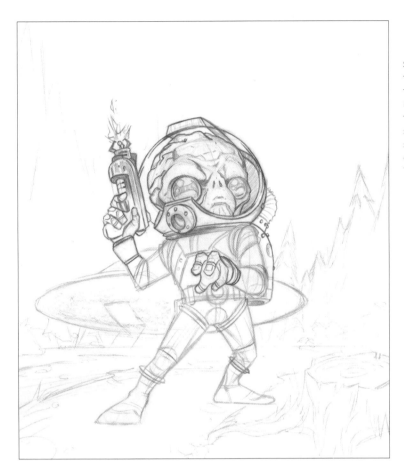

Step 4 Now switch to a 2B mechanical pencil to start filling in shadows and defining the rivets and folds in the cloth, erasing construction lines as you go. Use the light from the ray gun and ambient moonlight as the two sources of light, with backlighting from the spaceship. Leave areas of white near the edges of some forms to suggest reflected light, which will help define forms in shadow and give a fuller feel to shapes. Then create lighter areas by lifting out graphite with a kneaded eraser.

Step 5 Continue to define the alien and his surroundings with the 2B pencil. When adding shadows to the background, make sure to keep all light sources in mind. For instance, the ray gun is too far away from the background to cast any light on it. Instead, the light source in the background will come from the glowing open door.

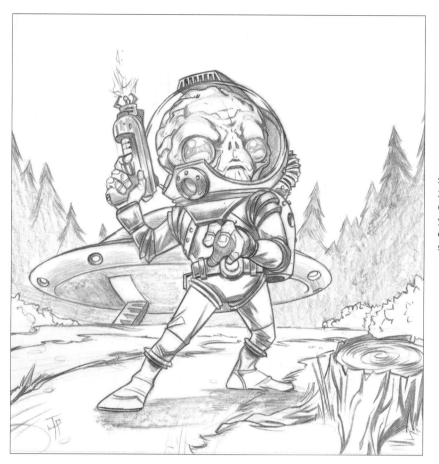

Step 6 After darkening all of your lines with the 2B and developing the rest of the background (especially the spaceship and trees), clean up your edges with a kneaded eraser. Then add details to the spaceship, and create a cast shadow underneath the alien to ground him.

Mad Scientist

Dr. Jekyll, Dr. Frankenstein, Dr. Moreau: Where would we be without our mad scientists? These are the new purveyors of the bizarre and terrible curses on humanity: science gone awry. The challenge here is to show both madness and discovery.

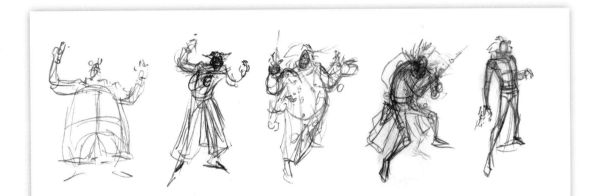

Concept Sketches
A look of madness is essential for this character, but to convey discovery and scientific elements, choose a pose that captures the "Ah-ha!" or, rather, the "It's alive!" moment.

Step 1 Sketch the pose with a 2H pencil. Here the character crouches with a test tube held up in a moment of evil celebration. Lightly block in the basic forms, establishing the placement of the hands, feet, and head. Draw centerlines down forms to show direction and volume. Then block in the lab coat.

Step 2 Still using the 2H, build up the clothing and details of the face and hair. Most of the figure is in costume, but remain conscious of the forms underneath. Next develop the face, coat, and boots.

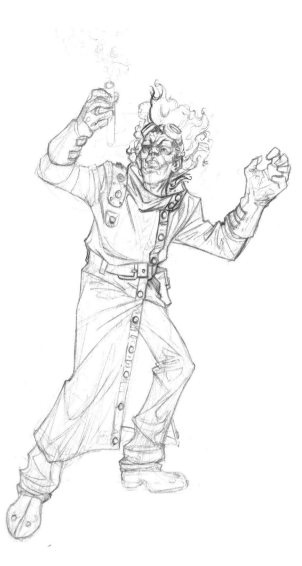

Step 3 Now put a bit more pressure on the 2H pencil to go a step darker, and outline edges, fill in more details, and add texture. Notice how the stress points of the coat are at the shoulders where the arms are raised; there are also stress points at the waist where the coat is buttoned across the hips. Next lightly sketch some equipment at the back of his belt.

Step 4 With all the main forms in place, erase some construction lines and start in on the final lines, beginning with the face. The scientist is older and gaunt, so the structure of the skull is prominent. Next add shadows, using the beaker as the light source.

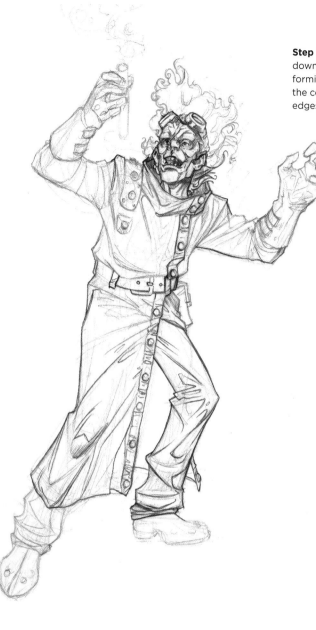

Step 5 Switch to a 2B, and continue moving down from the head, finding shadows and forming edges. Add stress lines and folds to the coat. At this point, focus mainly on edges and forms.

Step 6 Now use straight, tapering strokes to build up the hair. Still using the 2B, move into the arm on the right, building up the fabric folds. Keep this drawing pretty open if you plan to color it.

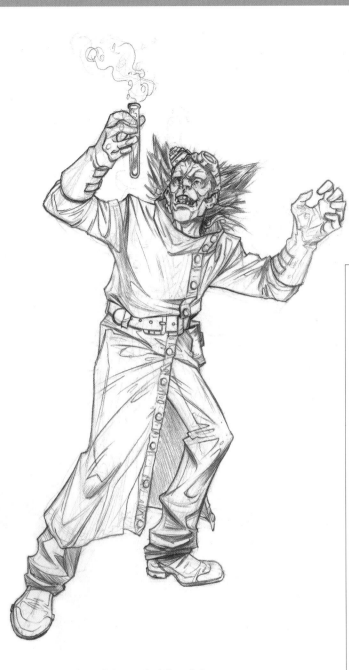

Step 7 Finish outlining and adding slight shadows where they help define form, again leaving it open for the color stage, if desired. Finally, lay in a few large shadow shapes, and clean up with an eraser.

Hydra

A hydra is a many-headed dragon. It can have as few as seven or as many as one million heads! The hydra has notoriously bad breath because it exhales poison or acid. This monster often inhabits rivers.

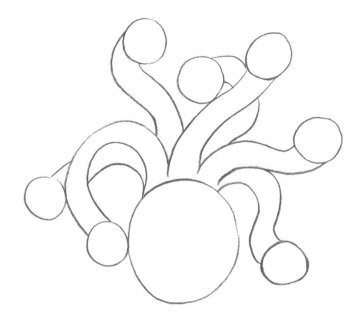

Step 1 Start by using a 2H pencil to draw the basic shape of the hydra. Your main concern in this step is to make sure all these heads can exist on the same body in a plausible way!

Step 2 Draw the legs and feet, which at this point look like a robot's. Then continue building the shapes, adding facial guidelines to the heads. Then delineate the fronts of the necks with lateral lines.

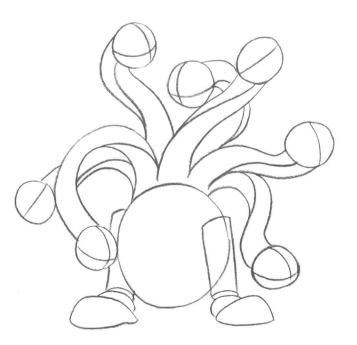

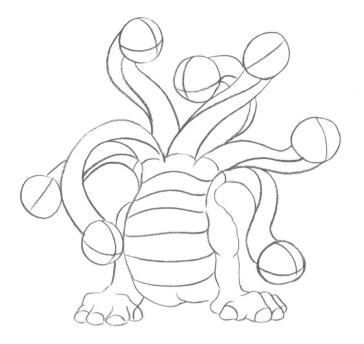

Step 3 Using your construction lines, refine the legs and feet. Make the feet a cross between a human's and an elephant's, with large, squarish nails. Then add horizontal lines on the torso that curve with the body's form.

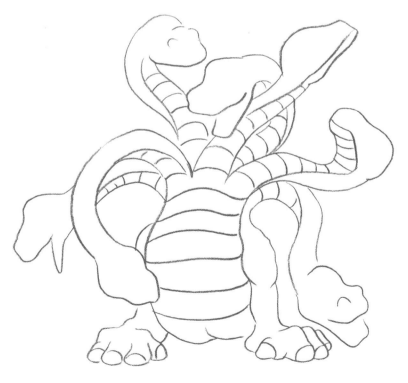

Step 4 Continue the curved lines up the fronts of the necks, refining the heads as you go and erasing any construction lines, as you no longer need them. These heads are quite rounded, rather than angular—similar to those of baby dinosaurs.

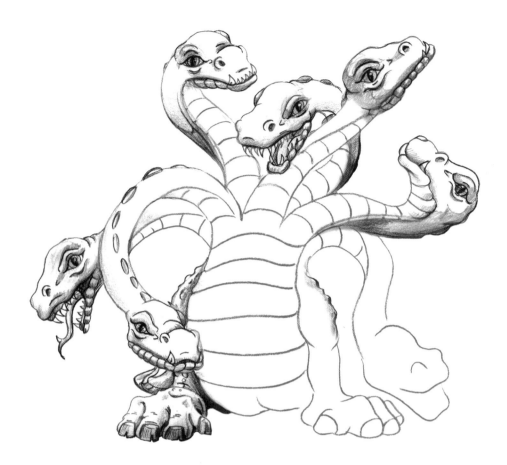

Step 5 Using a 2B pencil, add facial features and tone to six of the heads. Try to give each head a different personality while maintaining general uniformity, varying their poses and features. When adding tone to the heads, lightly rub the graphite with a paper towel to create a simple gradation. Draw ridges on some of the necks, and then move to the creature's haunches, adding a rough, bumpy texture. Continue this texture down the creature's right leg and onto its foot. Add small circles to enhance the texture, and draw very unkempt toenails.

Step 6 As you continue to build up the overall tone with the soft graphite, make sure not to grind it into the paper so that you can blend the tone later. Then shift your attention to the belly scales, shading them and blending with a paper towel. Continue the bumpy texture down the creature's left leg, and apply the same ragged-toenail treatment to the creature's left foot.

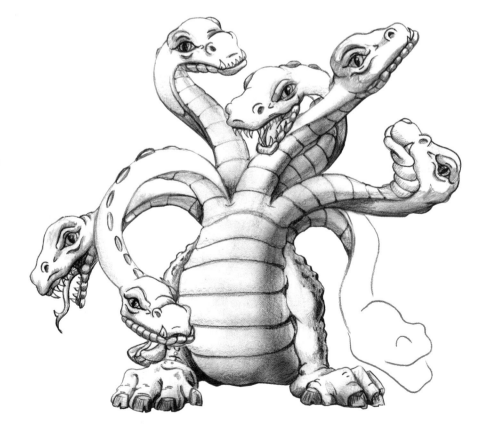

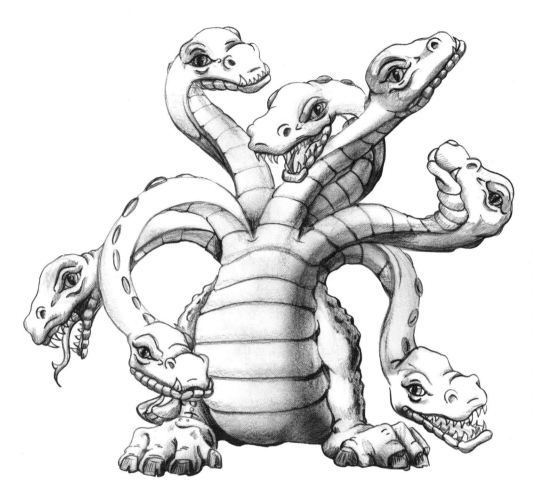

Step 7 Now render the final head, and use a paper towel to blend heavy areas of graphite throughout, creating dark, rich, even tones. Run a vinyl eraser along the contour edges to clean up any stray marks. Then use the eraser to pull out highlights; use a craft knife to carve specialty shapes in your eraser so you can reach tight areas.

Cyclops

Cyclops, a giant with a single eye in the middle of its forehead, originates from Greek mythology. In Homer's epic poem *The Odyssey*, the cyclopes live as a community of shepherds and blacksmiths in what is now Sicily.

Step 1 With a 2H pencil, draw the basic shapes of the figure's torso, head, and arms, which are raised above the head.

Step 2 To convey a sense of power, block in the legs with a wide stance.

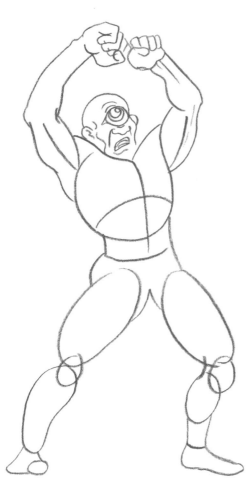

Step 3 Add a guideline across the chest to suggest curvature. Then refine the arms and hands, making them large and beefy. At this point, switch to a softer HB pencil to add the facial features. Make the nose extra wide to balance the oversized eye.

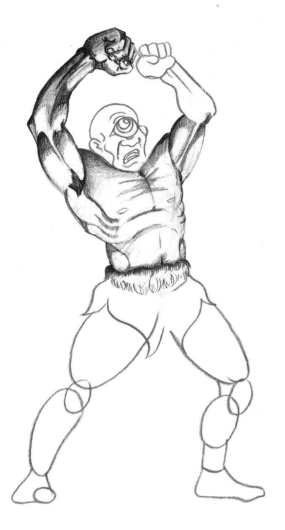

Step 4 Still working with an HB pencil, draw the outline of the loincloth, which barely covers the muscular thighs. Then add the furry band at the top, using short, curved strokes. Now begin shading the upper portion of the cyclops with a 2B pencil. Define the muscle groups of the beast's right arm, shading them so they appear to be lit from below. Progress to the torso, keeping the darker tones in the upper portions of each interior body shape.

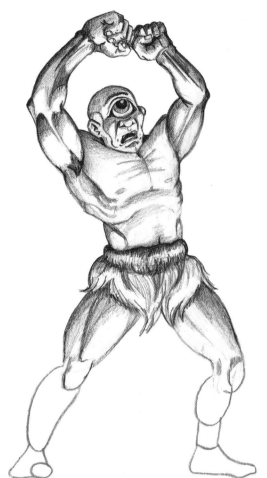

Step 5 With the 2B pencil, shade and detail the face, saving the darkest values for the curving eyebrow and the large pupil. Then continue to add tone to the rest of the body. Make the shadows on the upper body darker than those on the lower body, which is closer to the light source. Using a very sharp point, render long, wispy hair on the loincloth, curving around the thighs.

Step 6 Now refine the bottoms of the legs and the feet. Separate the toes, and draw large toenails. Add curved shadows on the calves to make them bulge. Then add tone to the tops of the feet.

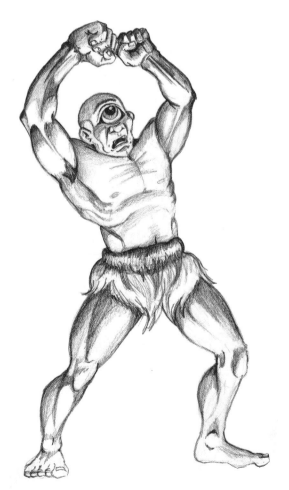

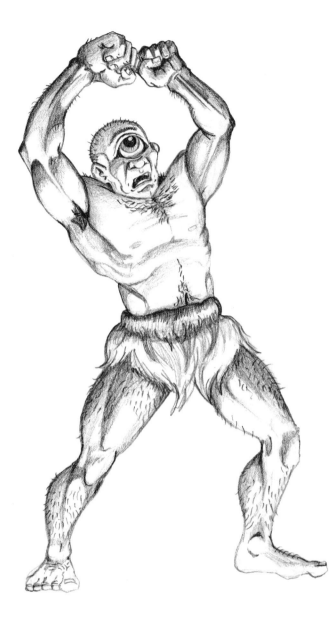

Step 7 For an added treat, add patches of hair to areas such as the arms, the top of the head, the chest, the torso, and the legs. You can even add some stubble to the tops of the feet!

Centaur

The centaur of Greek tradition is a part-human, part-horse race; it is untamed and ill-behaved because its animal nature conflicts with its human side. When offended, Zeus, the leader of the Olympian gods, unleashes this wild creature on gods and mortals alike as punishment. Centaurus, one of the god Apollo's sons, is believed to be the founder of the Centaur race.

Step 1 Start by using a 2H pencil to assign shape and form to the centaur. Draw it in a pose that plainly represents both the equine and human aspects of the character, as it creates a recognizable silhouette. Use these underlying forms to make certain that the two parts of the creature line up appropriately.

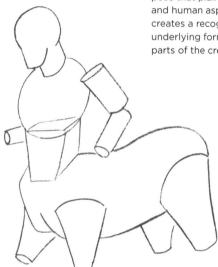

Step 2 Before adding the facial guidelines, draw boxes for hands and cylinders for legs. Then draw the tail, and add the hooves. Use a good equine reference to better understand the way a horse's legs taper.

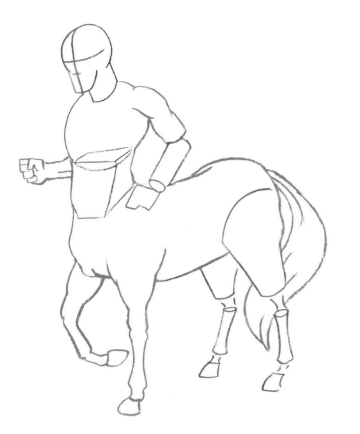

Step 3 Using the simple shapes as guidelines, begin to refine the forms of the creature. Start with the beast's left shoulder, and move down to the right hand and the forelegs. Then refine the rear, including the tail.

Step 4 Continue building the body, including the beast's left arm, chest, torso, and rear legs. Although centaurs aren't real, horses and people are, so use plenty of good reference material to make a convincing creature. Following the facial guidelines, add the features. Then draw the hair and beard.

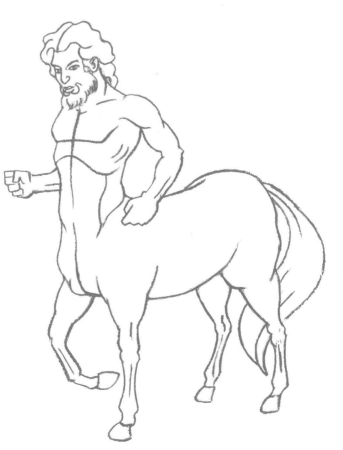

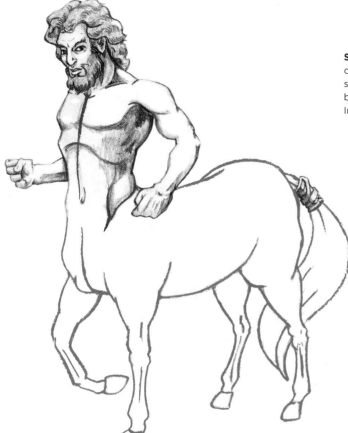

Step 5 Start shading the human portion of the centaur with a 2B pencil. Try to give its hair a slightly untamed appearance. Its beard also is a bit bristly and uneven, giving it a wild aspect. Include a wrap at the base of the tail.

Step 6 Before finishing the human half, start shading the equine half, indicating the horse's musculature. Once the tone on the equine half is caught up to the human portion, you'll add final details to both sections at once. This creates a more integrated appearance.

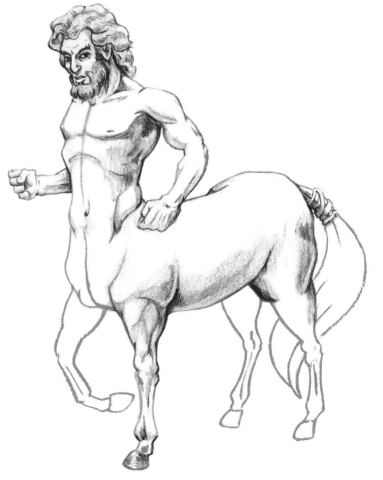

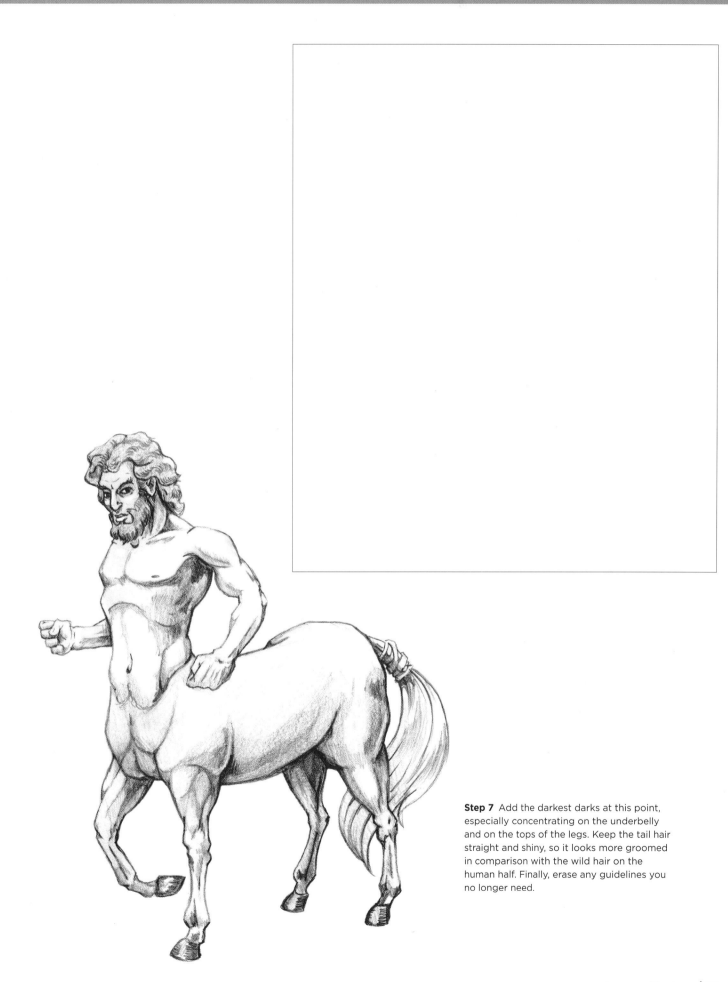

Step 7 Add the darkest darks at this point, especially concentrating on the underbelly and on the tops of the legs. Keep the tail hair straight and shiny, so it looks more groomed in comparison with the wild hair on the human half. Finally, erase any guidelines you no longer need.

Troll

Originating in Scandinavian folklore, the troll is imposing but dim-witted and easily duped. Because it is unpleasant to be around, other creatures usually avoid the troll. Commonly found living in caves or under bridges, the troll is adept at fortune-telling and shape-shifting.

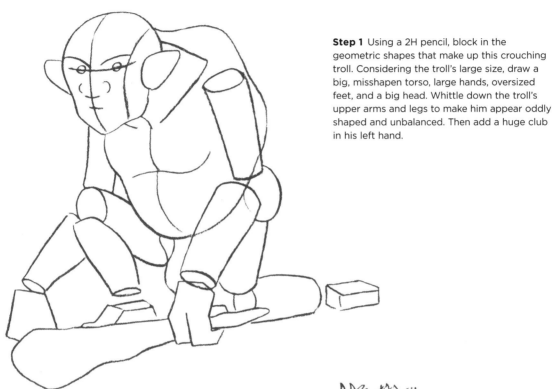

Step 1 Using a 2H pencil, block in the geometric shapes that make up this crouching troll. Considering the troll's large size, draw a big, misshapen torso, large hands, oversized feet, and a big head. Whittle down the troll's upper arms and legs to make him appear oddly shaped and unbalanced. Then add a huge club in his left hand.

Step 2 To give the troll a little character, start refining its facial features. Fill in the beady eyes, add a bulbous nose, accessorize the ears, and draw a mop of unruly hair. Try to create the appearance of a stupid brute, not a ravenous monster.

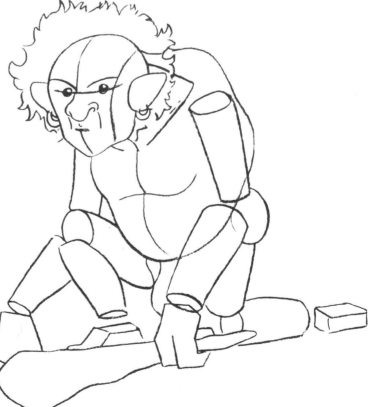

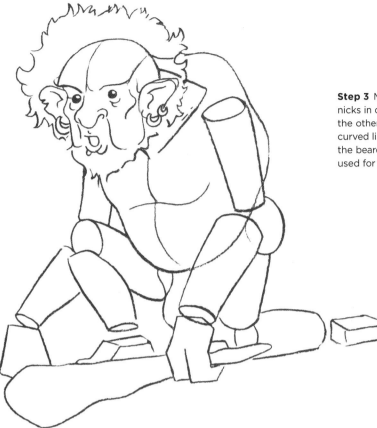

Step 3 Modify the ears a bit, creating a few nicks in one and adding a second earring in the other. Draw the small, open mouth and curved lines for the drooping chin. Then add the beard, using the same types of strokes used for the hair.

Step 4 Refine the shapes of the chest, back, arms, and hands. Then erase the remaining construction lines on these areas and the face. Next extend the hair over the forehead, and adjust the brow ridge.

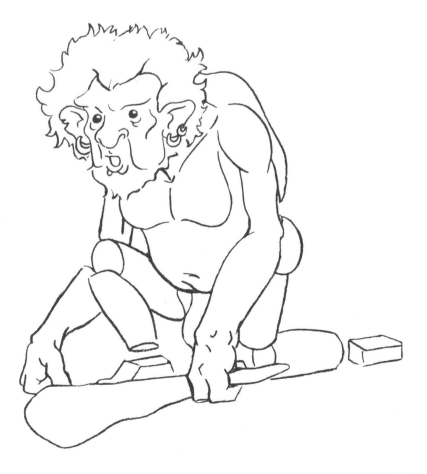

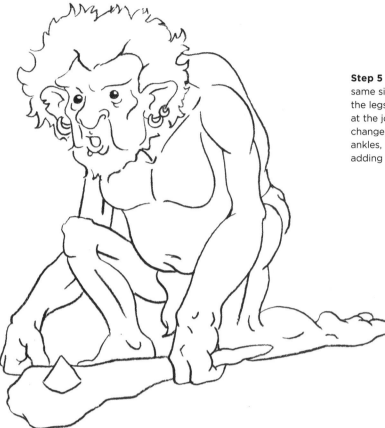

Step 5 To finish refining the body, follow the same simple recipe used on the arms. Make the legs full and round but knobby and angular at the joints. This means that the lines tend to change direction a lot more around the wrists, ankles, elbows, and knees. Refine the club, adding a sharp spike on the tip.

Step 6 Create depth on the troll's body by building tone with a 2B pencil. Consider approaching the image in sections. For instance, shade the face until it is done; then move on to an arm, then a leg, and so on. This can be beneficial in keeping the anatomy clear and distinct.

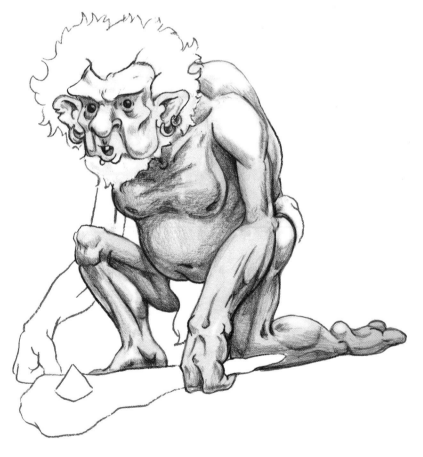

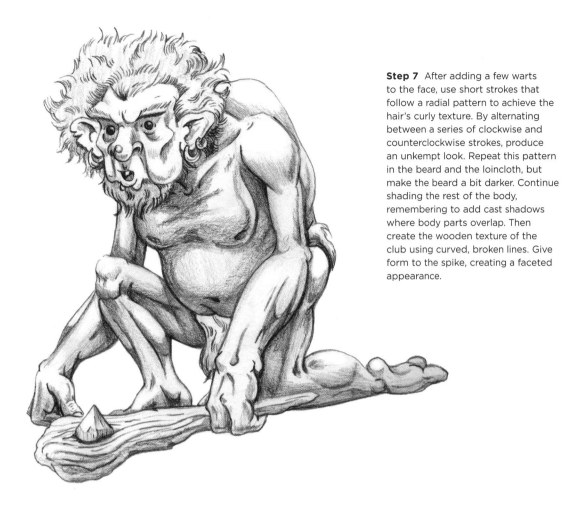

Step 7 After adding a few warts to the face, use short strokes that follow a radial pattern to achieve the hair's curly texture. By alternating between a series of clockwise and counterclockwise strokes, produce an unkempt look. Repeat this pattern in the beard and the loincloth, but make the beard a bit darker. Continue shading the rest of the body, remembering to add cast shadows where body parts overlap. Then create the wooden texture of the club using curved, broken lines. Give form to the spike, creating a faceted appearance.

Werewolf

The lycanthrope, or werewolf, is a human with the ability (under his control or not) to turn into a wolf-like creature, complete with sharp claws and teeth, superior hearing and smell, and a lack of remorse about killing humans. The full moon is often associated with this change and is featured in many werewolf stories, but it is not a part of all werewolf mythologies.

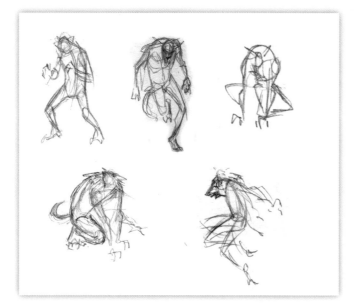

Concept Sketches This figure is engaged in a nice, loping run—a bestial jog. This pose is deceptively casual yet threatening.

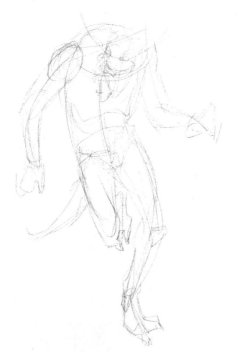

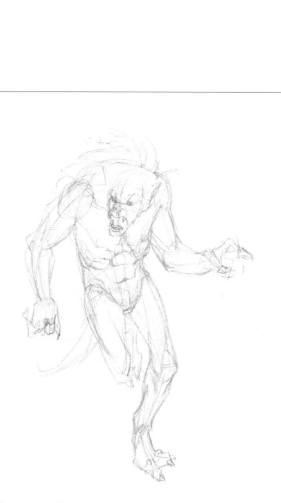

Step 1 Begin sketching the figure's basic pose, noting the movement of the spine, the relation of the hips to the shoulders, the placement of the limbs, and the distribution of the weight. With the 2H, lightly start drawing the major forms. The hands are positioned so that the figure is running with his hands clawing through the air. The major forms of the head indicate the direction and expression.

Step 2 Now focus on specific details, noting major muscles and anatomy, and begin to draw some of the surface anatomy. This character will be covered in fur, but make sure the underlying anatomy is solid before you start laying in fur patterns.

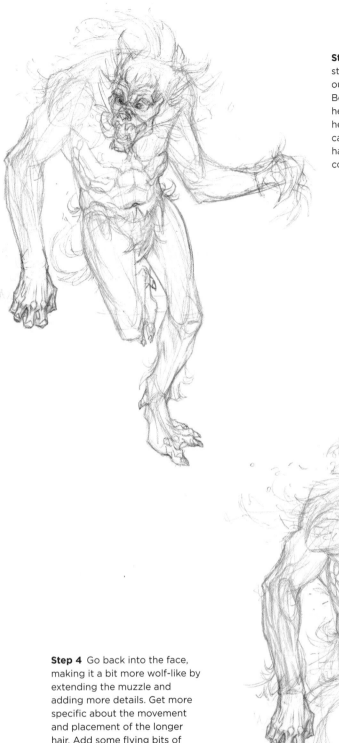

Step 3 Starting with the face, go a step darker with the 2H, working out the personality of the beast. Begin to sketch the hair on the head and body. Get a bit detailed here, placing the forms of the rib cage and surface muscles. The hands are important, as you need to convey the movement of his body.

Step 4 Go back into the face, making it a bit more wolf-like by extending the muzzle and adding more details. Get more specific about the movement and placement of the longer hair. Add some flying bits of detritus to communicate movement, and reposition the tail to add to the flow of the figure. Make the raised hand a bit relaxed; he's not attacking now, but he could at any moment. Perhaps he's playing with his food.

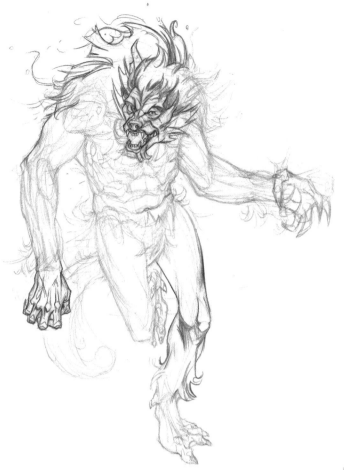

Step 5 Use a 2B pencil to work out the shapes of the face and the fur on the shoulders and back. Then draw the left knee and right hand and add shadows.

Step 6 The figure is lit from above, so move through the rest of the body with this in mind. Accentuate the powerful creature's muscles, making his forearms a bit long to give the impression that he can run on all fours in a semi-upright position. The flowing hair fur and the hard muscle forms contrast nicely, so continue the idea and try to make interesting shapes in the hair.

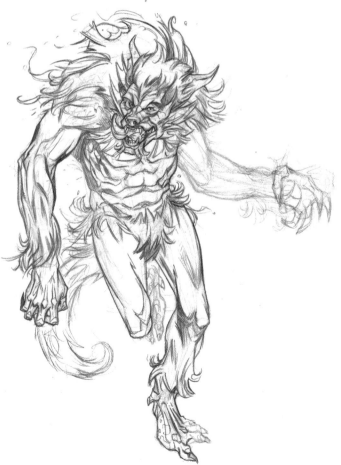

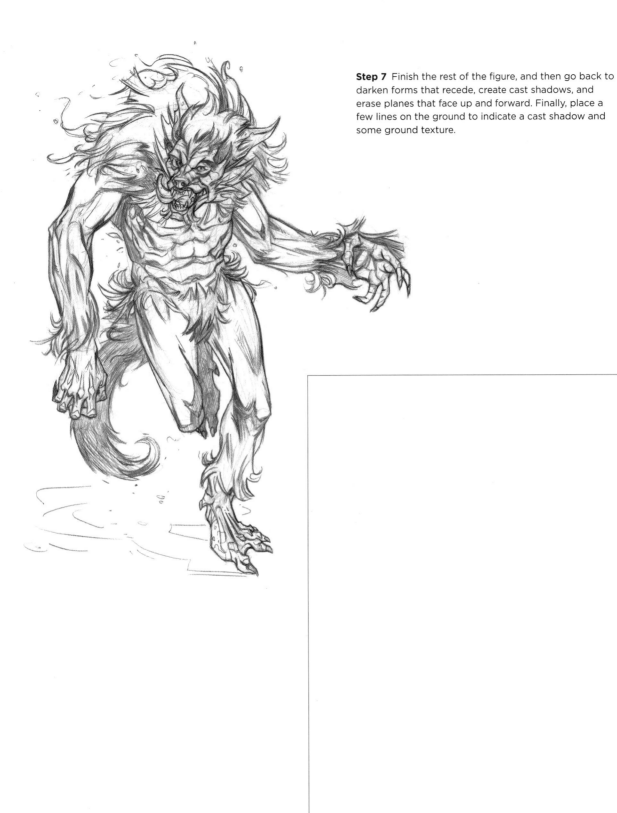

Step 7 Finish the rest of the figure, and then go back to darken forms that recede, create cast shadows, and erase planes that face up and forward. Finally, place a few lines on the ground to indicate a cast shadow and some ground texture.

Vampire

Modern Western folklore holds that most vampires are charming and elegant with an air of decrepit age and ancient evil. At their best, vampires are able to attract and repulse victims at the same time. Depictions of vampires greatly vary in popular culture, and the bloodsucking undead are used as analogies for all sorts of human behavior. As story elements, they possess a seemingly endless well of melodrama built into the conflict between their once-human existence and their true vampire nature.

Step 1 Lightly sketch the pose with a 2H pencil, starting with the centerline (or line of action) and a few lines to define the torso, legs, and arms. Aim for a general idea of the proportions and position of the figure; don't worry about being too exact because you will most likely move everything around a bit as you develop the character.

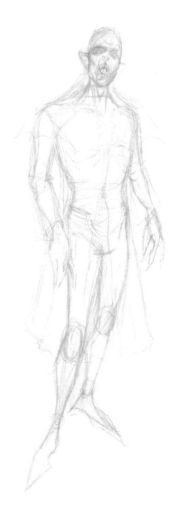

Step 2 Establish the angle of the head, and start defining major areas of the figure, including the coat. Give the character a sinuous body with signs of age and atrophy, exaggerating joints and bone structure, especially in the hands, feet, and face. Study the proportions of elderly men for reference.

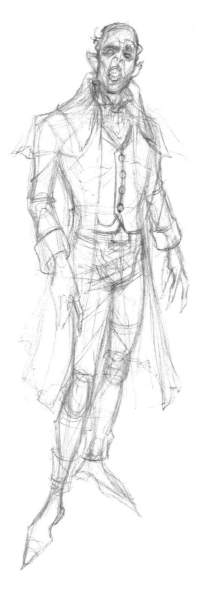

Step 3 Vampires are depicted in all kinds of costumes and clothing; this character is from the Edwardian/Victorian era, so develop a coat with some details reminiscent of armor. The clothing should have a kind of dapper and aged look. Start to experiment with the vampire's hair and facial expression.

Step 4 Still using a 2H, continue developing the costume and figure. Fully capture the facial expression and textures before you start placing final lines, as they'll be harder to erase. His hands should look aged and powerful; more lizard or rat than human. Make the knuckles large, the veins prominent, and the fingers sharp. Then begin adding details to the coat, pants, and shoes.

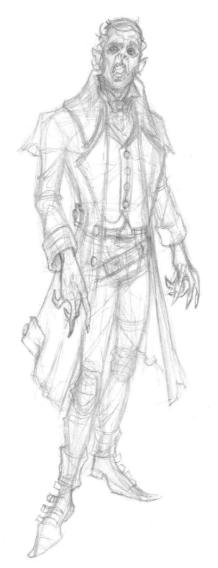

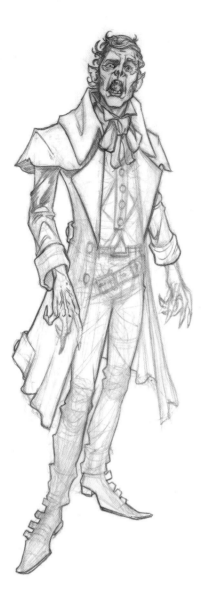

Step 5 Now switch to a 2B to start darkening lines and adding shadows, erasing construction lines as you go. Add curving lines to the hair to show motion. Then refine the shape and size of the bow at the neck.

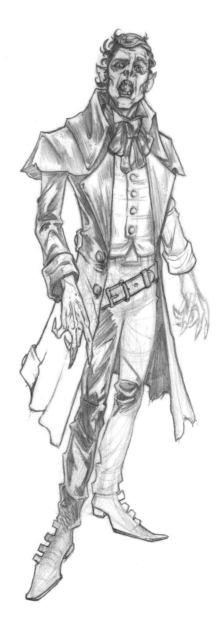

Step 6 Continue working up shadows and filling in dark areas of the clothing, leaving white areas for highlights. Then add frayed edges to the coat to show age.

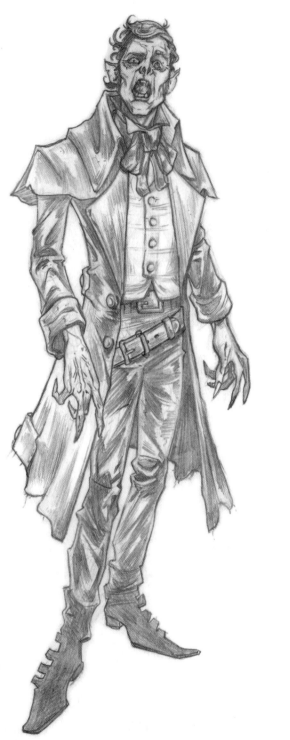

Step 7 Finish adding details and refining the figure, making the vampire's fangs more prominent. Make the hands look especially veiny and ancient, complete with long, sharp nails. To finish, use a plastic eraser to clean up edges and create more areas of highlights.

King of the Dwarves

In personality and culture, dwarves are almost the exact opposite of the lean, carefree elves who use magic to maintain their lifestyle. The rugged dwarves are not gifted magically and many times cause magic to fail. Practical and hard working, they find joy in the toil of building vast networks of tunnels and crafting items of supreme strength and power. Other than their ability to extract and manipulate ore, dwarves are known for being fierce in battle (commonly wielding large double-headed axes) and their huge beards.

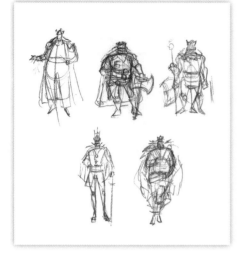

Concept Sketches
Imagine the king of the dwarves as being outfitted in full plate armor and bearing an axe on his back.

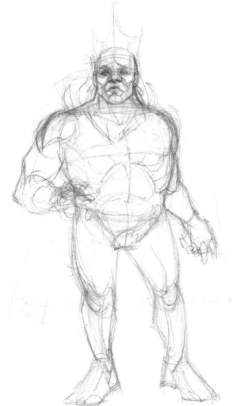

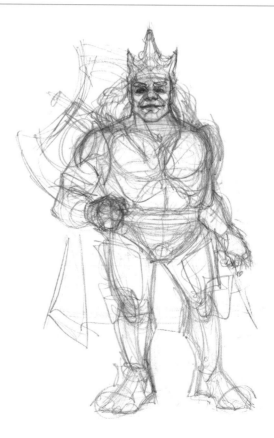

Step 1 With the side of a 2H, lightly sketch the pose, making the figure look short and squat. Then add the basic forms and major points of anatomy. Next sketch the face and some of the costume, including the crown.

Step 2 Using the side of the pencil again, sketch lines for the hair, costume, axe, and massive beard. Work back into the face to widen the jaw, and then develop the crown further.

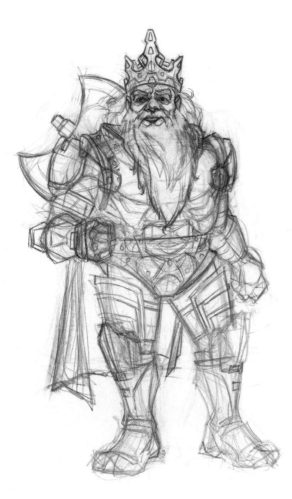

Step 3 Place more pressure on the 2H, and find edges and basic shapes for the armor, drawing through forms to make sure they wrap around the body and look convincing. Work on the face a bit more, exaggerating the loose skin under his eyes and drawing wrinkles to suggest his age.

Step 4 Blot the figure with a kneaded eraser to clean up construction lines. Then switch to a 2B to start laying in the final lines, starting with the head. As you develop edges, use the side of the 2H to place shadows. Since there are several layers of overlapping forms, this will help you see how they combine as they are developed.

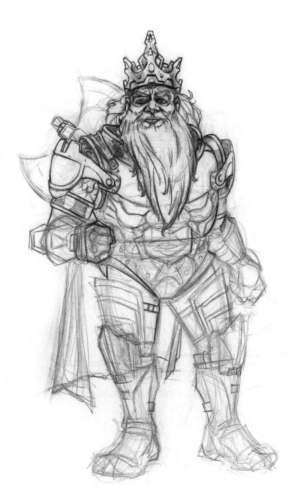

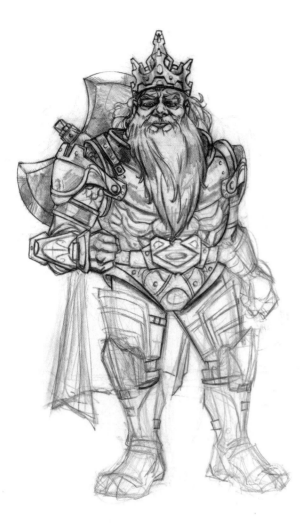

Step 5 Increase the outer edges of the axe blades, using a circle template for the edges. Further develop the armor, and then go back in with the 2H to add shadows, which will help you see how the forms are reading.

Step 6 Continue the process down through the lower half of the figure. Then go back into the shadows to build up some darker areas, and erase light shapes to better simulate a reflective surface.

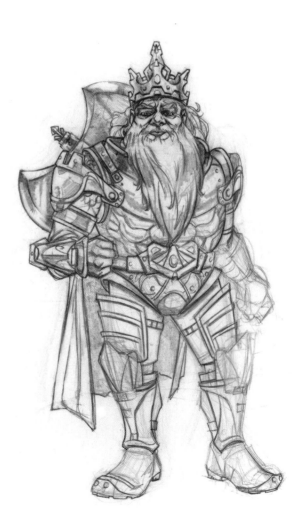

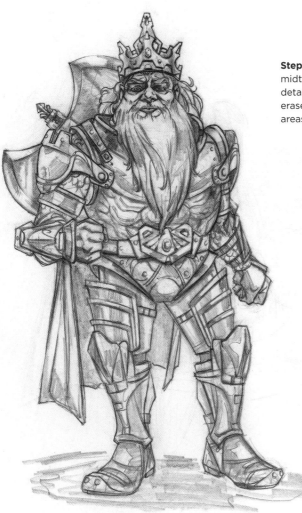

Step 7 Use the 2H to create more shadows and midtones, and then go back in with the 2B to add details and extra texture. Then use a hard plastic eraser and a kneaded eraser to lighten up any areas that have been overworked.

Quarto.com • WalterFoster.com

© 2023 Quarto Publishing Group USA Inc.
Artwork on front cover, back cover (bottom), and pages 2, 12, 14-17, 36-65 © 2009,
2010, 2013 Jeannie Lee; back cover (top) and pages 1, 8-11, 18-35, 112 © 2013 Bob Berry;
pages 3, 84-99 © 2007 Michael Dobrzycki; pages 4-5 © Diane Cardaci; pages 6-7,
66-83, 100-111 © 2010 Jacob Glaser; and page 13 © 2010 Mike Butkus.

First published in 2023 by Walter Foster Publishing, an imprint of The Quarto Group,
100 Cummings Center, Suite 265D, Beverly, MA 01915, USA.
T (978) 282-9590 **F** (978) 283-2742

Walter Foster Publishing titles are also available at discount for retail, wholesale,
promotional, and bulk purchase. For details, contact the Special Sales Manager by
email at specialsales@quarto.com or by mail at The Quarto Group, Attn: Special Sales
Manager, 100 Cummings Center, Suite 265D, Beverly, MA 01915, USA.

ISBN: 978-0-7603-8470-1

Cover design by Burge Agency
Copyedit by Elizabeth Gilbert
Proofread by Caitlin Fultz

Printed in China
10 9 8 7 6 5 4 3 2 1

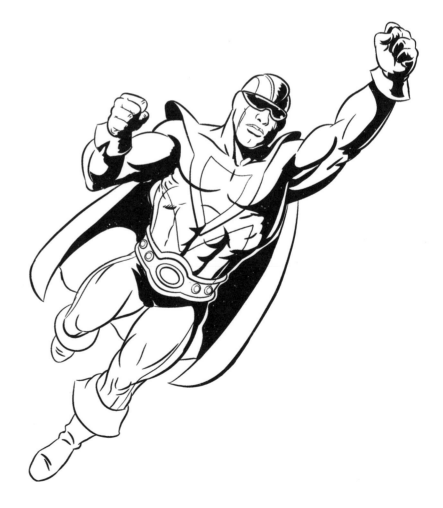